HALIFAX
PUBS

VOLUME TWO

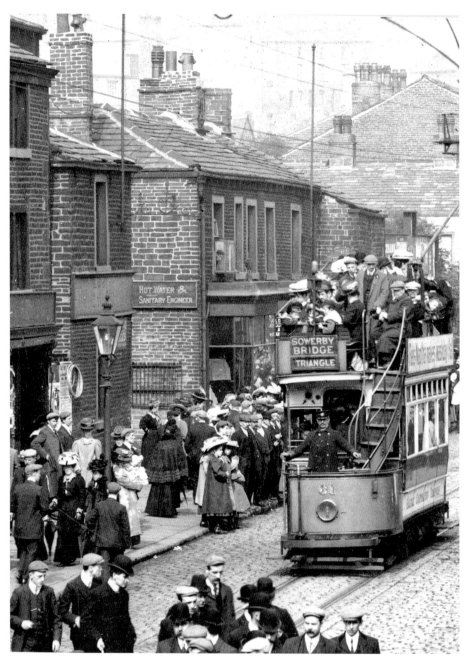

Commercial Inn and the Red Lion Inn, Sowerby Bridge.

HALIFAX PUBS

Volume Two

STEPHEN GEE

AMBERLEY

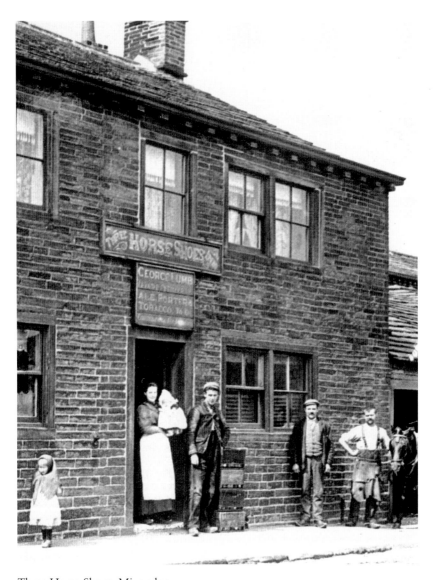

Three Horse Shoes, Mixenden.

First published 2011

Amberley Publishing
The Hill, Stroud
Gloucestershire GL5 4EP

www.amberleybooks.com

Copyright © Stephen Gee 2011

The right of Stephen Gee to be identified as the Author
of this work has been asserted in accordance with the
Copyrights, Designs and Patents Act 1988.

ISBN 978-1-4456-0242-4

British Library Cataloguing in Publication Data.
A catalogue record for this book is available from the
British Library.

Typeset in 10pt on 12pt Sabon.
Typesetting and Origination by Amberley Publishing.
Printed in the UK.

Contents

	Acknowledgements	6
	Introduction	7
1.	Halifax Town Centre	9
2.	Around Halifax	29
3.	North of Halifax	49
4.	Brighouse and Surrounding Areas	65
5.	Elland and Surrounding Districts	81
6.	Down the Calder Valley	91
7.	Sowerby Bridge and the Ryburn Valley	109

Acknowledgements

I would like to express my thanks to all the photographers who captured the images used in this book. Without these, this book would not have been possible. I would also like to thank the staff at Calderdale Central Library for their assistance during my research and to those at our local papers, past and present, who continue to produce a valuable record of events. I also extend my thanks to Whitbread plc for allowing me full access to the Whitaker's archives.

Thank you to the many people who provided odd snippets of information as I took the opportunity to question them on pubs and local happenings. In particular, Peter Robinson's help and information has been invaluable.

Finally I would like to extend a special acknowledgement and thanks to my partner, Joyce, who has yet again displayed great patience during my research and has supported and encouraged me during the writing of the book.

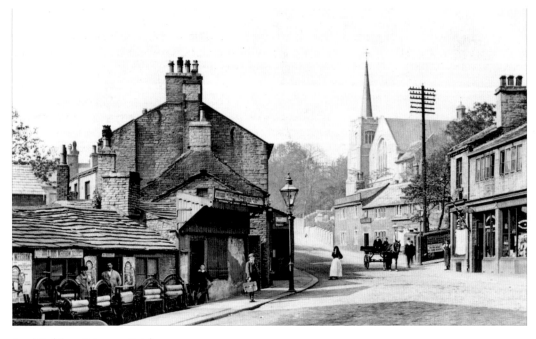

Sun Dial Inn, Briggate, Brighouse.

Introduction

Volume one of *Halifax Pubs* had many common themes, including celebrations, meetings, pub trips and celebrity visits. Other events covered were the corn riots and the riots following the 1832 parliamentary elections. Coiners, who would clip the edges off coins and use the clippings to produce counterfeit coins, also featured several times throughout the book. The public houses covered in the first volume were at the centre of these events, incidents and happenings.

This second volume of *Halifax Pubs* incorporates a totally different set of pubs but, like the first, they were also at the centre of many events, notably royal visits, galas, processions and outings. The coiners once again feature, not surprisingly given the coinage readily available from accommodating landlords. Other events covered are the plug plot riots, the Brighouse riots of 1882, various murders, and the inquests that were held at public houses, often into fatal and sometimes bizarre accidents.

Many of our pubs owed their existence to the Licensing Act of 1830, after which, for a fee of two guineas to the local excise officer, householders were allowed to sell beer. This had the impact of dramatically increasing the number of beerhouses in the country. Halifax was no different. Countless beerhouses opened throughout the parish as many households took the opportunity to supplement their income by brewing and selling beer. This was brought under some control by the 1869 Wine and Beerhouse Act, which required retailers selling beer and wine, to obtain licences from justices.

However, by the end of the nineteenth century, the government still felt that there were too many beerhouses and this drove the Licensing Act of 1904, which allowed justices to refer pubs for compensation on grounds of non-necessity, more commonly referred to as redundancy. Many of the pubs in this volume became 'victims' of this overriding desire to reduce the number of outlets. Objections to renewal of licences were heard at the annual brewster sessions and as the drive to close premises became relentless, the reasons for objections were often dubious. Defences, perhaps based on little hope of success, were often fairly imaginative.

Although infrequent, the bench did sometimes support the landlord, as in the case of the Victoria Tavern in Brighouse. Annoyed that the justices had referred the pub so many times, the judges took the extraordinary step of declaring that if the Victoria was referred in future, they would continue to support the renewal of the pub's licence. Few pubs gained such support.

Many licensees lost their livelihoods, including the landlady, for twenty-five years, of the Railway Hotel at Ripponden, who was told her customers were 'largely tramps and vagrants'. The hotel was closed in 1906. The police efforts regarding the King of Belgium, Halifax, also deserve a mention. To the compensation authority of 1928, they declared that in the fifty-two times they had visited the pub, they had counted only 486

customers and 109 of those were female. The inn was subsequently closed. In 1930, the Victoria and Albert Inn, Haley Hill, suffered the same fate. Following forty-two police visits, in twenty-two days, only 458 customers had been counted. 161 were women.

This gender balance of the clientele was a common theme at the brewster sessions. Opposition to renewal often involved a statement of how many females frequented the pubs and a question regarding their integrity. The Black Swan, Silver Street, was in 1919 'used by both men and women, the latter being of doubtful character'. Regarding the Craven Heifer, Cow Green, Halifax, a 1918 report was blunter. The singing room was found to be full of soldiers and women, including prostitutes. By 1925, the number of pubs closed due to redundancy and the compensation scheme, in Halifax alone, had reached fifty.

In 1939, the landlord of the York Inn, Charlestown Road, gave little objection to his pub being referred – the York had been demolished six months previously.

It is strange how attitudes change; many will still remember that day in 1969 when the last men-only pub in Halifax, Lewins, opened its doors and welcomed female drinkers in for the first time since the First World War. Drinking habits also change; they have been recently influenced by the availability of lower-priced drinks at outlets other than public houses and amendments to licensing laws, smoking bans etc. Despite the continued adversity, the parish of Halifax still has a large number of excellent pubs, continuing a tradition going back hundreds of years.

The public house has always played a central part in the everyday life of the district and the photographs in this volume will help rekindle memories of past events, incidents and celebrations, or simply of the hostelries themselves, past and present, illustrating once again their importance to the town and parish.

1

Halifax Town Centre

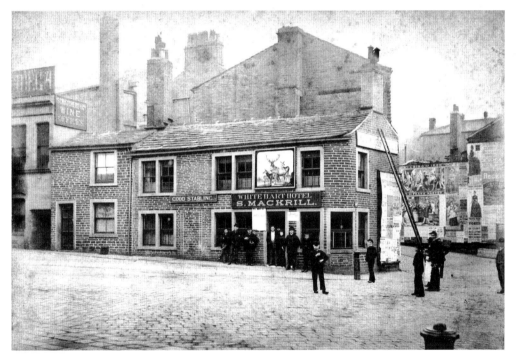

The White Hart, Halifax, was the subject of lengthy negotiations between Whitaker's brewery and the Halifax Corporation in 1895, resulting in the corporation paying £9,000 for the premises. The pub was clearly in the way of road improvements – it was situated at the bottom of Bull Green and extended across what is now the road to Cow Green. The Adega premises of wine dealership Scratcherd & Co. are on the far left. This photograph was taken around 1887, when Samuel Mackrill was landlord of the White Hart.

Whitaker's was first offered the Griffin Hotel, occupying the corner of George Street and Barum Top, in 1898, on a seven-year lease of £350 per annum. The company eventually purchased the hotel, along with the tobacconist and chemist's shop, in 1925. In this photograph a car is parked outside the hotel, while another has just passed George Street; further on is the original Bull's Head Hotel, which was replaced by new premises in 1940.

The Beehive & Cross Keys, King Cross Street, was designed by local architects Walsh & Maddock and built, in 1932, for Whitaker's brewery. The pub took its name from the two inns run by the Swift family, the Beehive Inn and the Cross Keys Inn, both demolished as part of the developments and road improvements in the area.

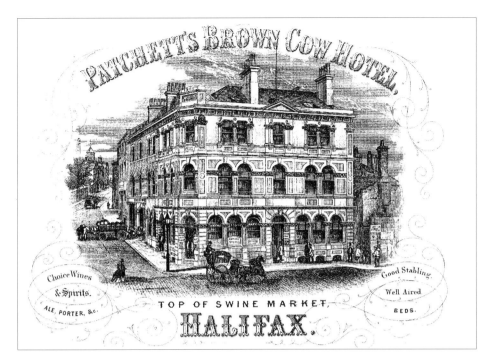

The Brown Cow Hotel, in Swine Market, opened in 1864, replacing an inn of the same name that was located nearby in Copper Street, which closed in 1863. William Crabtree Patchett had been the landlord of the old Brown Cow and was licensee of the new building until George Greenwood took over in the late 1860s. In June 1880, when it was in the occupancy of Thomas Greenwood, the hotel was put up for auction along with its wine and spirit vaults, brew house and stables.

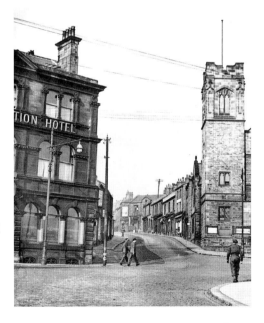

When the Brown Cow Hotel was put up for auction in 1880, it was advertised as being 'centrally situated at the junction of six principal thoroughfares'. No doubt it was this location that led to it being renamed the Grand Junction Hotel shortly afterwards. The pub, by then a Ramsden's house, closed on 28 January 1968 and was demolished as part of the Cow Green road-widening and redevelopment scheme.

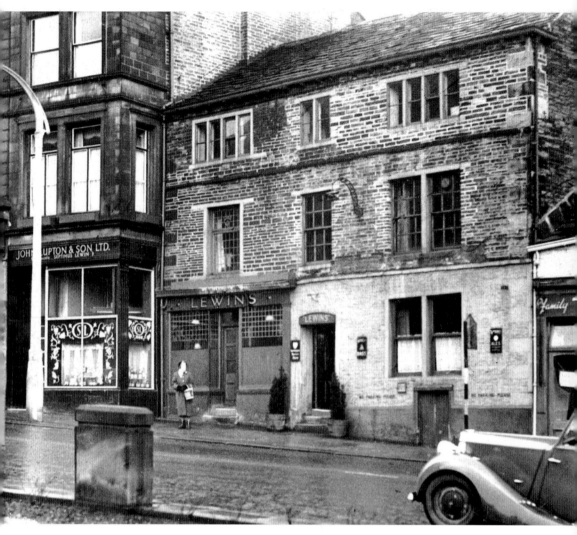

Built in 1769, Lewins in Bull Green was originally called the Hare and Hounds. In the 1880s, Septimus Lewin took over the wine and spirit business of Joseph Wadsworth and the attached pub, where Wadsworth was also the landlord. The Lewin family ran both businesses for over fifty years, until John Lupton bought out the family wine and spirit business in 1940 – although he retained the premises and continued to sell under the Lewin brand name. The pub continued to operate as the Hare and Hounds until the refurbishments of the late 1960s, when it adopted the name Lewins. In August 1996, it commenced a four-year spell as an Irish-themed pub, O'Neill's, and then reverted back to the Lewins name in 2000.

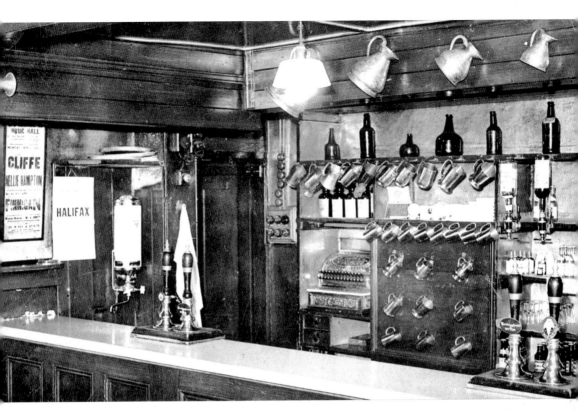

September 1965 signalled the end of one of the last all-male bastions in Halifax when the new owners of Lewins, Bass, Mitchells & Butlers, appointed a new landlord, Alan Robinson, along with his wife, Patricia. Cries of 'she won't be the last' and 'there'll be a mixed lounge next' were to become true when, after extensive refurbishment, Bass opened the pub to women for the first time since the First World War. The first female customers, Wendy Calvert and Belinda Darwin, entered the pub on 7 August 1969, the date of the official reopening. Personal tankards and beer jugs no longer hung behind the bar and the 'inner sanctum', known as the Royal Room and the Calcutta Room over the years, would never be the same again.

A policeman carries out traffic duty in Bull Green, with the Crown & Anchor Inn behind him. The pub was bought by Whitaker's in 1918 and subsequently transferred to Whitbread following the company's takeover of the Halifax brewery. The pub has had many different names, including the Adega, the Continental Bar and Heath's. It is now the Tequila Mexican Restaurant.

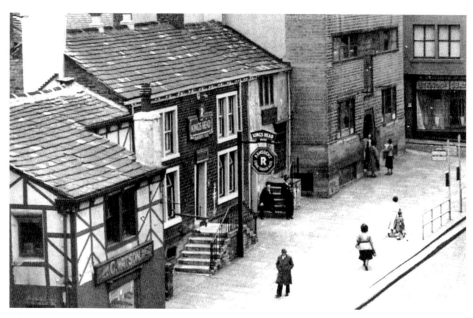

The King's Head, opened in 1822, joined the many other pubs in the area that catered for the farmers who brought their livestock to the cattle market, which was held at Cow Green until 1858. The pub was well known for its two sets of steps, which would have originally been used, without the handrail, for mounting and dismounting horses. Running parallel to Cow Green behind the King's Head was Back Street, one of the few local streets that also had cobbled pavements. The pub closed in 1968.

The Oddfellows Hall opened in 1840 and incorporated a 'commodious' inn, the Royal Hotel, with stables, a coach house, and bedrooms for visiting members.

On 6 July 1860, at the Halifax Borough Court, the landlord of the Royal Hotel, Benjamin Mortimer, was found guilty of Adulteration of Beer by the use of grains of paradise. Found guilty of the same offence at the same court were James Morton of the Hope Inn, Winding Road; Richard Edmondson of West Hill Tavern, California; and Samuel Whitehead of the Crispin Inn, Causeway. Each was fined £50. William Toone, a druggist of Woolshops, was fined £125 for supplying the grains.

The use of grains of paradise had commenced many years earlier as a means by brewers to reduce the excise duty payable on hops. However, the severity of the fines showed how serious this activity was considered. In 1816, an act was passed, Geo. III. c58, that no brewer or dealer in beer shall have in his possession or use grains of paradise or *cocculus indicus* under a penalty of £200 for each offence; and no druggist shall sell them to a brewer, under a penalty of £500 for each offence.

The crackdown on the Halifax publicans and brewers did not stop with the above. The following Wednesday, 11 July 1860, the West Riding magistrates devoted a full day to hearing of cases. The court was crowded with people eager to hear the cases presented by the Inland Revenue. A further six publicans were fined £50 for use of grains of paradise and one publican was fined £75 for using both grains of paradise and *cocculus indicus*. Samuel Halstead of Copley Hall beerhouse was fined £100, again for use of both. The court stated, that it did not think him to be of good character. Halstead did not help his cause by stating that his beer did not make his customers drunk enough without putting something in it.

Regarding the Royal Hotel, Benjamin Mortimer had his licence challenged following his conviction and by 1863 Joseph Millward was the landlord. The Royal Hotel closed in 1962 with its licence being transferred to The Royal on Washer Lane. The building was demolished in 1963.

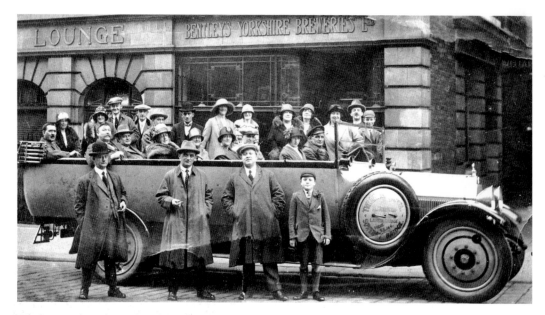

'The Lancia Coach', a charabanc belonging to H. Worsnop of Sowerby Bridge, waits outside the Victory Lounge, Silver Street, Halifax. In the 1940s, the main bar area of the Victory Lounge had brass grilles and glass shelves with marble tops. The tables were arranged into small drinking areas and each table had its own bell, which would call a smart, black-coated waiter to take your order.

The Victory Lounge, a Bentley's Yorkshire Breweries (BYB) house, had an out-sales department next to the main entrance and upstairs was a snooker and billiards hall. The Victory Lounge was sold in 1978 and then operated under several different names including Rosie O'Grady's and Foggy's, until Yates's opened a wine lodge here in 1992.

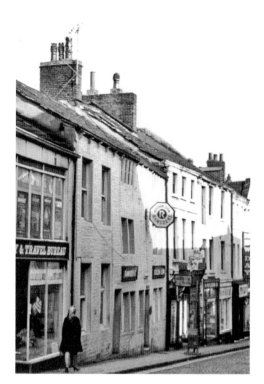

In October 1981, the Golden Lion, Cheapside, adopted its long-standing nickname the Brass Cat and in 1987 major rebuilding saw the adjoining premises incorporated. The new Brass Cat's added conservatory looks onto the renovated Upper George Yard.

The lady passing the Golden Lion door looks like she has been attacked by an urban fox. It is wrapped around her neck, with its legs, tail and head on show.

Whitaker's bought the Rose & Crown on Southgate in 1925. In 1956, the company sold the premises to Marks & Spencer, which two years later commenced its expansion towards Cheapside by demolishing the inn, which had occupied the site since the early eighteenth century, when it was known as the 'House at the Nook'. In October 1903, the then-landlord David Murgatroyd applied for a licence to provide an inside and outside bar at Savile Park for the Buffalo Bill show. His request was refused.

One of the earliest known photographs taken of Halifax town centre shows the old White Swan Hotel, which was located on Crown Street. The inn was demolished in 1858, along with the adjoining buildings, to make room for Princess Street. The area behind the hotel was the Swan Coppice, the wood taking its name from the ancient inn, with the coppice extending towards the area now occupied by the Halifax Town Hall; there was also a bowling green in this area. Above the White Swan sign is what looks like a light but was in fact a bunch of grapes.

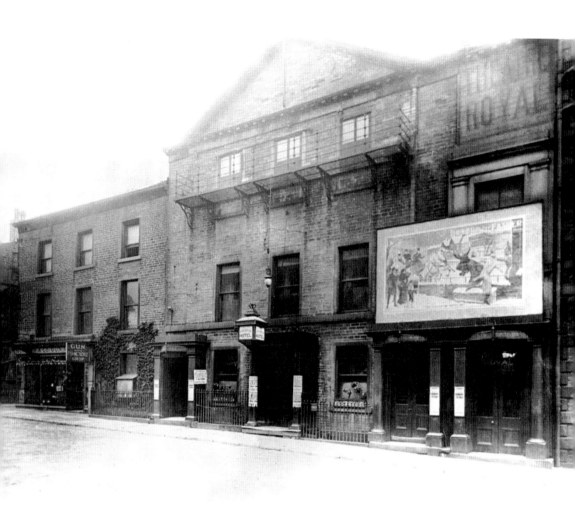

The Shakespeare Hotel was originally located next door to the old Theatre Royal at Wards End. The gallery of the theatre extended over the pub and theatregoers could access the bar from inside. However, in 1903, a new Shakespeare Hotel was built and as the posters on the pub's columns state in this photograph, 'business transferred to new premises in Horton Street'. The old Shakespeare Hotel and Theatre Royal were demolished, and a new theatre, occupying the whole of the old site, opened on 4 August 1905.

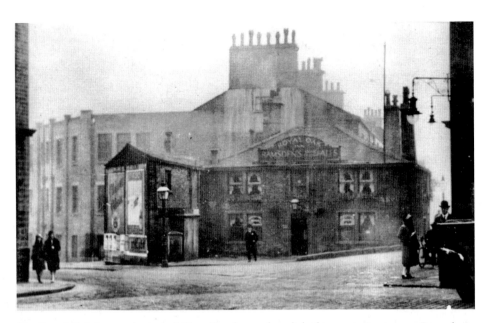

The Royal Oak Inn, at the end of Clare Road, was demolished in 1929. Its owners, Ramsden's, rebuilt the pub in a mock-Tudor style designed by Jackson and Fox using timber from the Royal Navy frigate HMS *Newcastle*. Still standing to the side of the pub is a milestone indicating that it is 198 miles to London. No longer readable are the distances to other places such as Huddersfield, Sheffield and Penistone – the stopping points of a coach that used this route.

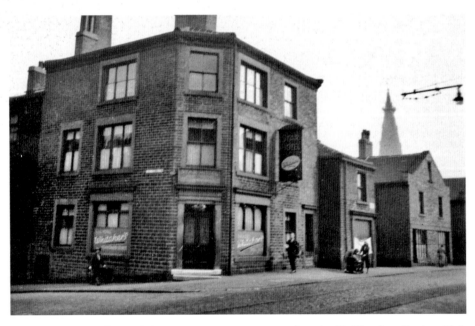

It was on the top floor of the Star Inn, Orange Street, that the Halifax Star Boxing Club was founded, by Bob Ennis, in the 1940s. The Star was one of Whitaker's earlier purchases, bought by them in 1868. The pub closed in 1998 and was demolished ten years later to make way for the Broad Street development.

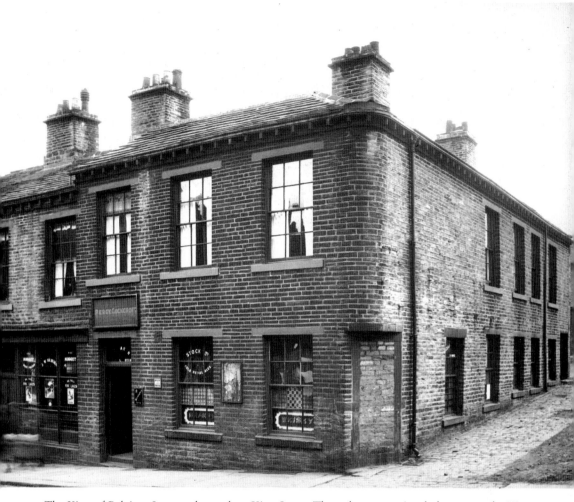

The King of Belgium Inn was located on King Street. The pub was previously known as the King of Prussia, after Frederick the Great, but was renamed during the First World War for patriotic reasons. The inn, a Joseph Stocks house, was referred due to redundancy in June 1928. At the Compensation Authority, it was stated that the police had visited the premises on fifty-two occasions, resulting in 486 customers being counted, 109 being women; the pub was subsequently closed.

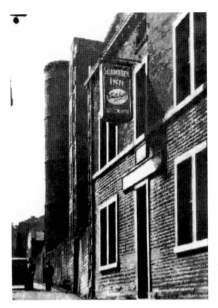

The Shamrock Inn was on the corner of Gaol Lane and Winding Road. An interesting bankruptcy case in 1909 gives an indication of the beer prices of the time. Ex-landlord Harry Ashworth was asked in court why, while running the Shamrock in 1908, he had sold his beer so cheap at 1½*d* per pint. He replied that he had made an attempt to charge 2*d* per pint but was losing customers as four other publicans nearby were charging the lower figure. They were not named but were possibly the Blue Bell, the Brighton Hotel, the Crown and Cushion Inn and the Hen and Chicken Inn. The Shamrock Inn closed in 1954.

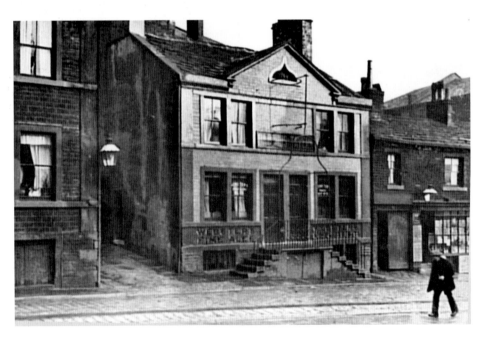

The Bacchus Tavern, built in the eighteenth century, was located on King Street. The Bacchus was one of the local inns frequented by the 'coiners' – criminals who clipped and diminished coins of the realm. In fact, the gang who met at the Bacchus even had the audacity to apply to the United Grand Lodge of England for a warrant and were successful. In 1769, the Freemasons granted a warrant for the Bacchus Lodge, much to the disgust of the Lodge of Probity in Halifax, who sent several strong letters urging the removal of the Bacchus Lodge. Despite many of the members fleeing the country or being locked up in prison for their activities, it took until 1783 before the lodge was removed from the Freemasons' list. The Bacchus Tavern closed in 1928 and the building was demolished in 1937.

The Hope Inn was located at Winding Road's junction with Cross Street. Whitaker's, who owned the pub, advertised another 'Hope' during the First World War, when restrictions had limited their production such that they could not cope with demand: 'Hope that the day is not far distant when they may render the same good service of the same good Honest Ale as in the dim distant days prior to the war.' The Hope Inn closed in 1971; the building is now part of the Inn-Cognito restaurant and wine bar.

The Cat I'th Window, on the corner of Lower Kirkgate and Berry Lane, opened in 1822. The photograph, taken from the coal drops, shows the pub on the corner and in the distance the turning to Clarke Bridge. The pub was purchased by Webster's in 1864 and was subsequently sold to the Halifax Corporation in 1928. Its licence was transferred to the new Shay Hotel.

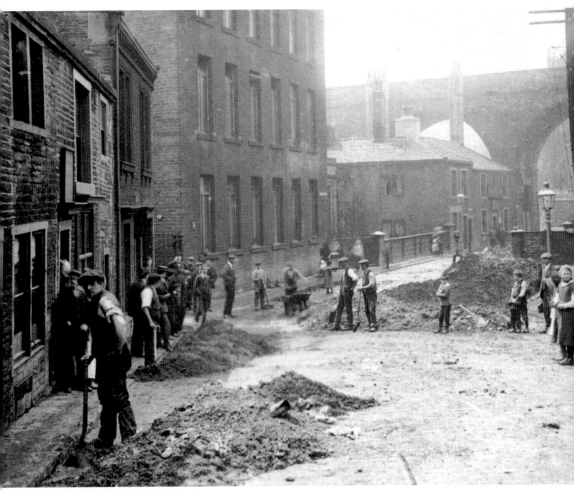

An area that had its fair share of pubs and beerhouses was Clark Bridge, Bank Bottom. Here, carrying out road repairs, are quite a few thirsty workers. There was no need to travel too far as the Duke William Inn was just by the viaduct. It closed in 1965. Closer to the camera is the Moulders Arms, which closed in 1921.

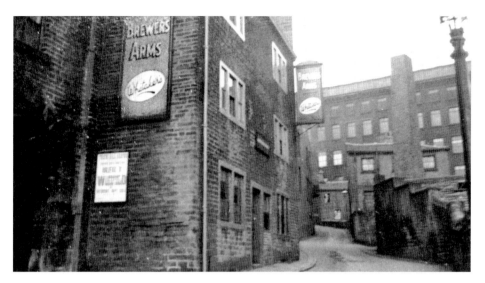

Overlooked by part of the massive Dean Clough Mills, the Brewers Arms was located in Crib Lane. It was in cottages at Crib Lane's junction with Seedlings Mount, as well as on the site of the former Stannary Inn, that Richard Whitaker originally carried out his brewing before purchasing the land to build his Seedlings Mount Brewery, later better known as the Cock o'the North Brewery. The Brewers Arms closed in February 1962.

The Commercial Hotel, Northgate, was bought by Whitaker's along with the nearby Bridge Tavern in 1918. In July 1875, John Cain, a labourer from Charlestown, was found guilty of assaulting the landlord of the Commercial. Cain and another man had been quarrelling and the landlord had ordered them out. They refused and, after much cursing and swearing, Cain struck and kicked the landlord. He was fined 47s 6d or the option to go to prison for two months. The Bridge Tavern premises were sold to Halifax Corporation in 1940; the Commercial Hotel closed in 1973.

The Great Northern Hotel stood at the bottom of Range Bank and took its name from the Great Northern Railway Company. The hotel, which catered for the passengers of the nearby North Bridge Station, would have seen trade suffer as rail passenger numbers dwindled. The closure of the station in 1955 would have been a decisive blow.

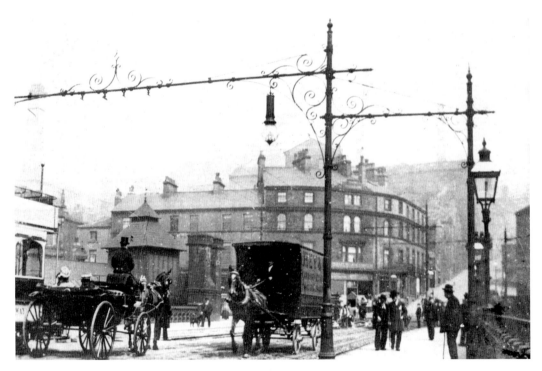

Located at the end of North Bridge, the Great Northern Hotel was an ex-Brear & Brown house bought by Whitaker's in 1916. The hotel closed in 1969 and was demolished to make way for the Halifax inner relief road.

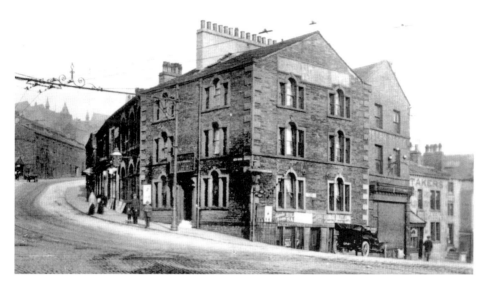

The Pine Apple Hotel was built around the same time as the new North Bridge, which opened in 1771. The hotel was built by William Baxter, 'an enterprising brewer', and was originally called the 'New North Bridge Inn' but, in 1779, Baxter changed its name to the Pine Apple Hotel. The Pine Apple became a Whitaker's house in 1926. A few doors away another Whitaker's pub can be seen, the Bishop Blaize Inn, which closed in 1935. The Pine Apple was demolished as part of the inner relief road work in 1968.

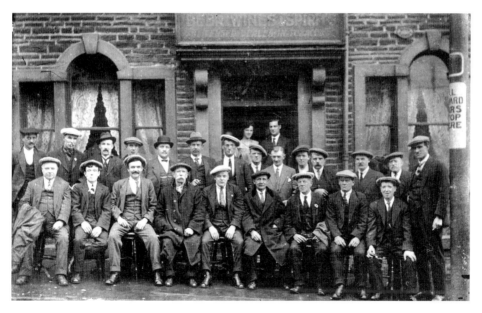

There is little to give away just what the occasion at the Pine Apple Hotel was. In most cases there is not even a smile, although the men boast some great headgear. The sign on the tram post reads, 'All inboard cars stop here.' Presumably this was instigated as a safety measure following the 1906 tram disaster, when a tram ran away down this point, negotiated the bend onto North Bridge, and toppled over – resulting in the death of two passengers and a further twelve being injured.

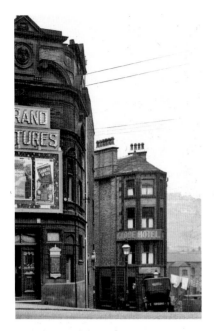

The Globe Hotel, located on North Bridge Street, was an ex-Brear and Brown pub purchased by Whitaker's in 1916. In 1939, the pub consisted of a vaults, bar, snug and smoke room, although the latter was not used apart from by the 'buffs' who had a lodge there – between forty and fifty members attended weekly. The pub was well fraternised by the theatregoers and performers from the Grand Theatre. Two years after the theatre closed, in 1956, so did the Globe Hotel.

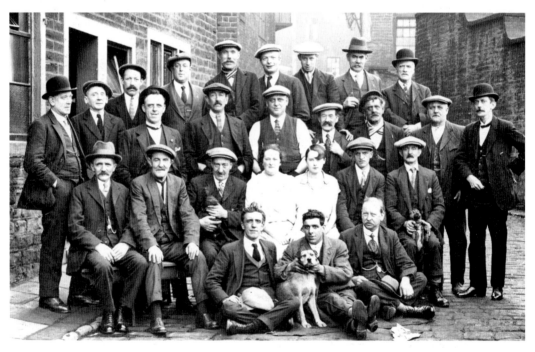

This postcard shows a nicely posed group outside the Devonshire Arms, Garden Street North, New Bank, Halifax. The message on the back of the card states that the landlord is in shirt sleeves and that his wife and daughter are sat in front of him. Unfortunately the message fails to name him, but it may be Albert Greenwood, who was the licensee in 1936. The Devonshire Arms was bought by Whitaker's in 1916. The pub closed in 1937 and the following year the property was sold by the brewery to the Halifax Corporation.

2

Around Halifax

The Coach and Horses Inn, Haley Hill, was purchased by Whitaker's Brewery in November 1886. It was at the pub in 1876 that the inquest into the death of nine-year-old Peter Keegan took place. He had died after suffering ill-treatment while working at Crossley's, Dean Clough. Despite eyewitnesses speaking against him, the overlooker responsible, Harry Crowther, was acquitted of manslaughter as there were no external signs of injuries. The pub remained a Whitaker's house until their takeover by Whitbread in 1968. In 2008 it was demolished to make way for a supermarket.

The Friendly Inn, New Town, Haley Hill, was bought by Whitaker's in November 1916. Originally opened in 1848, the pub was demolished in 1930 to widen Boothtown Road by 50 feet. A transfer of its licence to proposed new premises was accepted by the brewster session on 5 April 1930 and Whitaker's subsequently built a new pub adjoining the old premises. Richard Eastwood, who applied for the transfer of the licence, had run the pub since 1913, when he took over from his father, who had run the pub since 1881. In 2009, with the pub now closed, plans were submitted to convert the premises into a hot-food takeaway and dwelling house.

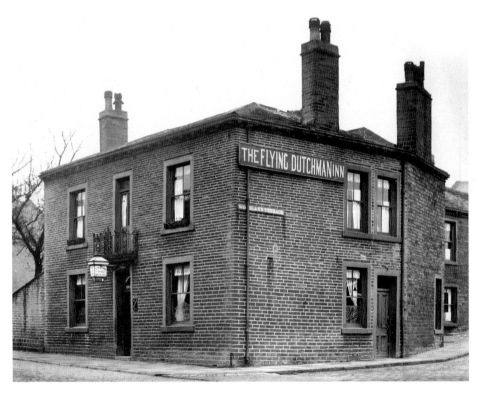

At the Great Court Leet, held at the Royal Hotel, Brighouse, in April 1860, the landlord of The Flying Dutchman, George Wood, was fined 10s for having two jugs that had illegal measures – a quart jug and a pint jug. At the same court leet, five other landlords from the Boothtown and Northowram areas were found guilty of similar offences. James Poole was the landlord when this photograph was taken. It shows the inn at the bottom of Woodlands Road, previously known as Dutchman Lane.

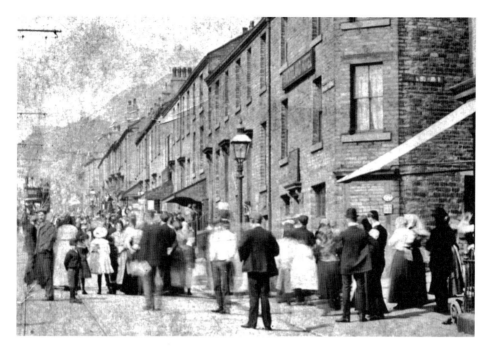

A large crowd stands outside the Woodland Hotel in Boothtown. Unfortunately for the landlord these people are not waiting for a drink, although some may have popped in once they had pelted the tramcar in the distance – it is one of the demonstrations of the 1906 tram strike. The Woodland Hotel, later the Woodland Tavern, was bought by Webster's, along with the Albert Springs Brewery, in 1877. The tavern was on the corner of Iona Street; further up the street was the brewery premises at the junction with Brewery Street. The Woodland Tavern closed in February 1971.

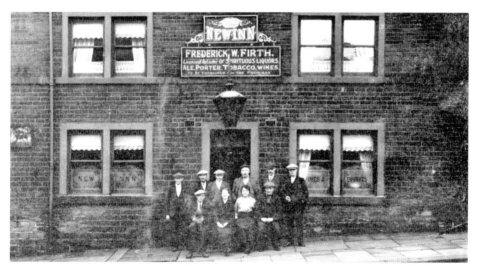

Frederick Firth was the licensee of the New Inn, Boothtown, in 1917, at around the time this photograph was taken. The inn was acquired by Webster's when the company purchased John Sykes' Albert Springs Brewery in 1877. The pub closed in 2006.

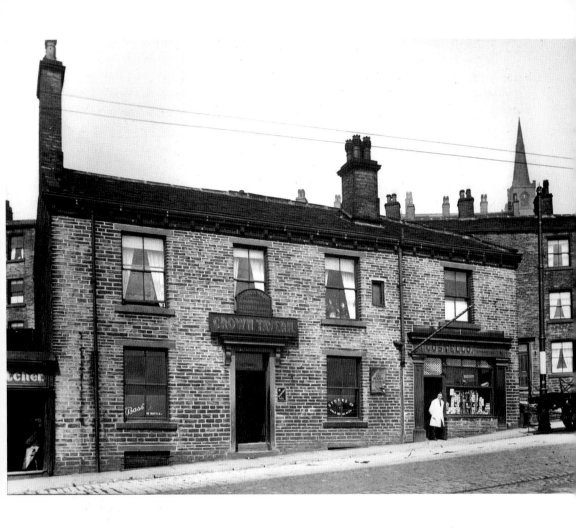

The Crown Tavern – seen here when it was a Joseph Stocks pub – was located in New Bank near its junction with Prospect Street. A delivery wagon, or dray, can be seen above Costello's, the gentlemen's hairdressers. The Crown Tavern, later a Webster's pub, closed in 1963.

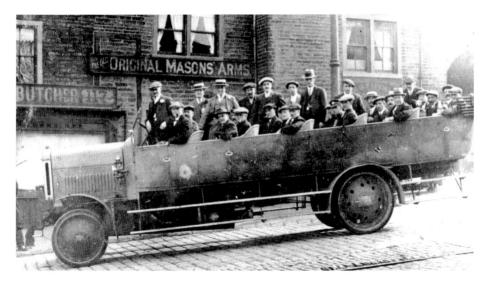

Waiting in their charabanc, this group are outside the Old Original Masons' Arms in New Bank, Halifax. Various forms of headwear can be seen, but only one person is wearing a uniform. This is William Henry Johnson, one of the first men in Halifax to sign up during the First World War. From 1927 to 1930, the renowned Herbert Seston, the real-life 'Doc Shire' (Whitaker's advertising figure), was the landlord. The pub, which was just below Holts Yard, on the right, closed in 1937.

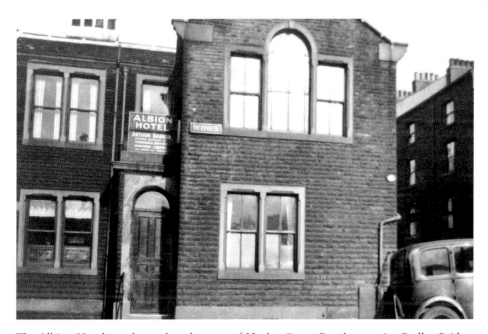

The Albion Hotel was located at the start of Horley Green Road, opposite Godley Bridge, Halifax. The pub, which opened in 1861, was bought by Whitaker's in 1926. Claremount Road is on the right of the photograph and just out of the picture on the opposite corner to the Albion Hotel was the Beacon Tavern, which closed in 1968. The Albion itself closed a few years earlier, in 1961.

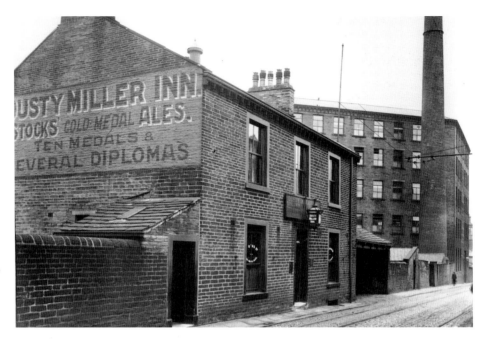

Closed in 1968, the Dusty Miller was located in Pellon Lane on the site The Running Man now occupies. Seen here as a Joseph Stocks house, it transferred to Webster's when they took over the Shibden Head Brewery. The sign on the side of the building advertises Stocks' Gold Medal Ales, winner of ten medals. Many of the pubs carried similar signs – I wonder if they all had to be repainted each time a new medal was won?

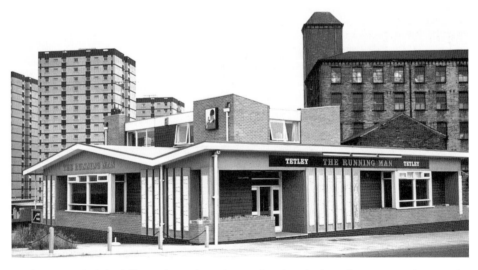

Looking just slightly different from the pub it replaced and whose licence it took over, The Running Man opened in June 1971. The name is taken from the nearby site of the renowned Halifax Gibbet and the story of John Lacy, who managed to escape having his head cut off by freeing himself and running beyond the Forest of Hardwick's boundary, to where the Bailiff of Halifax had no power to apprehend him. Unfortunately, seven years later, Lacy was foolish enough to return and he was recaptured. His head was subsequently dispatched.

The Claremount Inn fronted onto St Thomas Street, between Earl Street and Dover Street, Claremount. Originally a beerhouse, the pub opened in 1875. The Ramsden's pub was closed on 14 January 1969, one of the ten pubs that closed in Halifax that year. The district of Claremount was once known as 'Blackcar', which, in the view of historian John Lister in 1900, 'was much more appropriate, a good old honest name'.

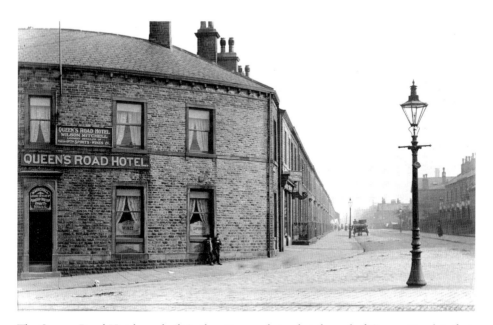

The Queens Road Hotel was built in the 1870s and stood at the end of Queens Road. In fact, locals knew it as the Queens Road End for many years before the name was officially adopted when the hotel reopened following refurbishment in May 1995. The pub was one of the Daniel Fielding's White Castle Brewery houses until Webster's took over the company in 1961.

The original approach to Pellon took almost a right-angle turn where the old Golden Pheasant Inn once stood. However, in 1931, a new road was made linking Pellon Station to Pellon New Road, which in effect bypassed what had been a fairly advantageous spot for the inn. The pub at the time was owned by Truman's, who responded by building a new Golden Pheasant Hotel, designed by Watkin & Maddox, alongside the new road. The premises of the old inn had been in existence from about the sixteenth century and were demolished as part of a Corporation Improvement Scheme.

At a special session of the licensing committee, held on 6 July 1932, a request was made to remove the licence from the old Golden Pheasant at Mount Pellon and transfer it to the newly erected premises. This was granted, which was fairly convenient as the new premises were to open that day.

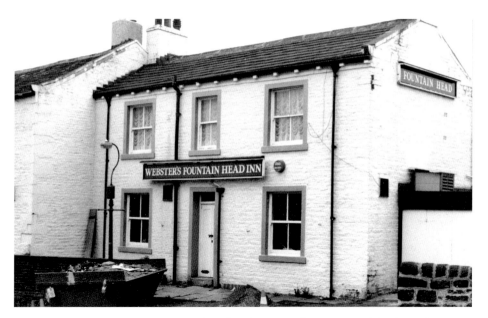

The Fountain Head Inn was originally a farmhouse, with ten acres of land, run by James and Susannah Webster, parents of Samuel, the founder of Webster's Brewery. It was here at Mount Pellon that, like many other farmers at the time, they commenced selling beer from their farm premises. In 1859, the property was bought by the Webster family but it was not until August 1899 that the Fountain Head Inn was transferred to Samuel Webster & Sons.

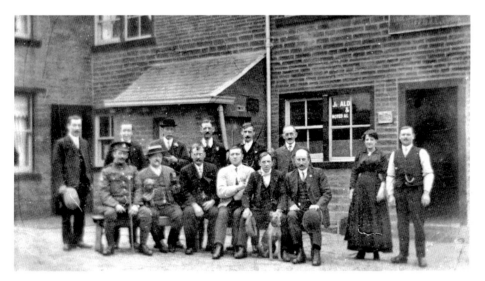

At the Halifax Brewster Session held on 4 February 1932, E. W. Hinchliffe, representing the landlord of the Half Way House Inn, Lewis Kenyon, stated that work was progressing with the rebuilding of the pub but that in order to maintain continuity of the existing licence it was being performed in two stages. A request to delay a transfer of the licence from the Elephant & Castle, Salterhebble, until the building was ready, and to allow the Half Way House Inn to sell all intoxicating liquor, was accepted by the justices. It was also pointed out that quite a large suburb had sprung up around the pub and a beer-only licence was inadequate.

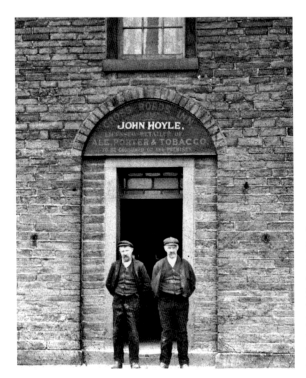

The Cross Roads Inn, Wainstalls, was built around 1864 and, like many pubs and beerhouses in the district, originally doubled as a farm. In this photograph of the pub as a beerhouse, the landlord John Hoyle is on the left. Historically, crossroads were where those who had committed suicide were buried; a stone cross was often erected at the site.

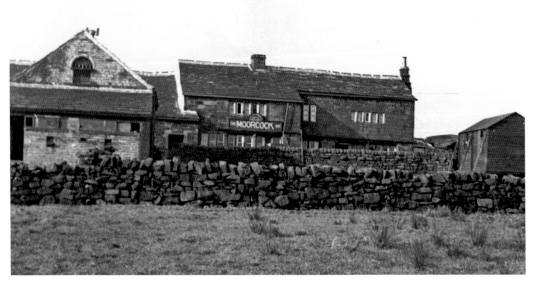

The Moorcock Inn, Wainstalls, is a listed building dating from the late seventeenth century. The inn was owned by Daniel Fielding & Sons (White Castle Brewery) until 1961, when it transferred to Webster's when the company took over the Bradshaw brewery. The inn started off as a beerhouse and changed little in over a hundred years' existence; it closed in 2002 and the property is now a private residence.

The Cat I'th Well, Wainstalls, dates back, as an inn, to at least the latter part of the eighteenth century; a property sale was held at the inn in 1783. During alterations in 1954, panelling was found relating to the Loyal Travellers Lodge, which was founded in 1833 and closed in 1869. It was here in 1885 that local 'preacher' John Preston was brought, having been found in an outhouse. But it was too late, as Whiteley Turner recorded in *A Spring-Time Saunter*: '... he had "clapped his wings" and his spirit had flown'.

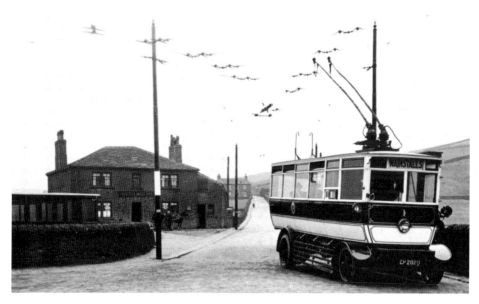

The New Delight Inn, Wainstalls, changed its name to its current name The Delvers in 1987. However, on an 1860 map it is marked as 'New Delight or Oddfellows Arms' – perhaps the proprietor could not make up his mind. The pub is on the old packhorse route to Haworth. A horse and cart can be seen outside the pub, while, in the foreground, a totally different form of transport can be seen: Halifax trolleybus No. 1. Halifax opened its trolleybus system between Pellon and Wainstalls in July 1921 but the venture was short-lived – the state of the roads took their toll and contributed to the early demise of the operation, which ceased in October 1926.

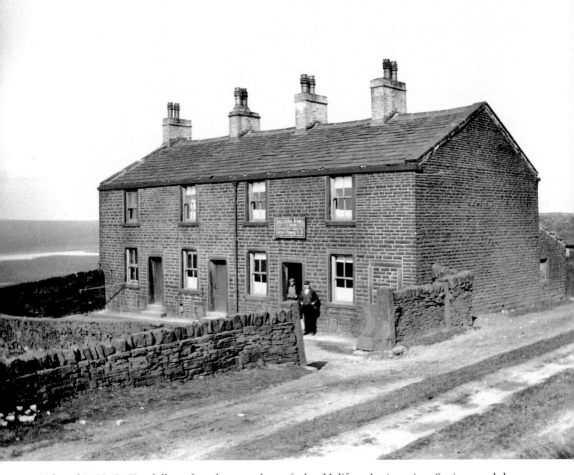

Taken by H. P. Kendall, a founder member of the Halifax Antiquarian Society and keen photographer, this photograph, from a glass slide, is of the Delvers Arms at Fly Flats. 'Delver' is an old name for a quarry worker and the area was renowned for its number of quarries. In the 1860s there were fifteen quarries employing 300 men and around sixty horses; between 30,000 and 40,000 tons of stone headed down to Luddenden Foot each year, all in horse-drawn wagons. The impact was such that a double iron track was laid between Fly Delves, where the Delvers Arms was located, and Wainstalls itself. All the houses along Withens Road, including the Delvers Arms, were reputedly blown up by the army to prevent further occupation and the potential contamination of the reservoir water by livestock.

Many films have been shot in Halifax and its surrounding areas. Perhaps one of the more famous is *Room at the Top*, based on the novel by John Braine and starring Laurence Harvey. It was filmed at the Halifax Town Hall, All Souls, Boothtown, and many other local sites. The pub scenes were shot at the Clarence Hotel, Lister Lane, in 1958 – the Clarence being a typical northern pub. The film did not go down well with all the people in Halifax; Archdeacon Eric Treacy apparently denounced it from his pulpit. The Clarence Hotel closed in July 2004.

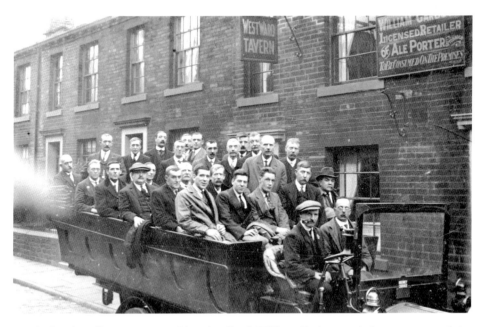

Ready for the off are – presumably – landlord William Garbutt and the customers of the Westward Tavern. The pub, which opened in 1897, was located on Crossley Terrace, near where a bomb landed in 1940. However, unlike many properties in the neighbourhood, the Westward Tavern survived. The pub closed in October 1969.

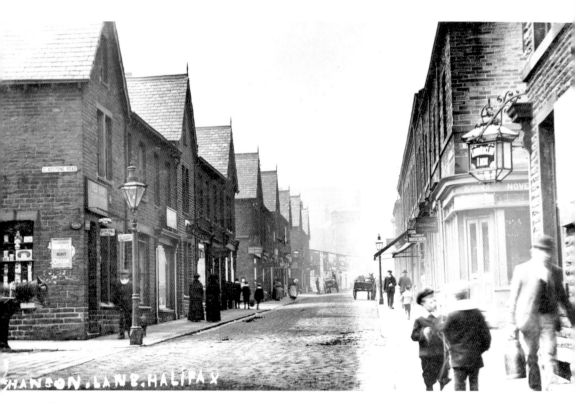

HANSON LANE HALIFAX

The ornate lamp, on the right, clearly shows where the Lord Raglan Inn was situated on Hanson Lane. In fact the gent walking past the pub looks like he may have just called in to fill up his can or jug. Further up Hanson Lane, on the right, was the West Hill Hotel, one of the many properties demolished and rebuilt after a bomb hit the south side of Crossley Terrace on 22 November 1940. Apart from the extensive damage to property, eleven people lost their lives and many more were injured. The West Hill Hotel closed in 1969; the Lord Raglan Inn closed in 1982.

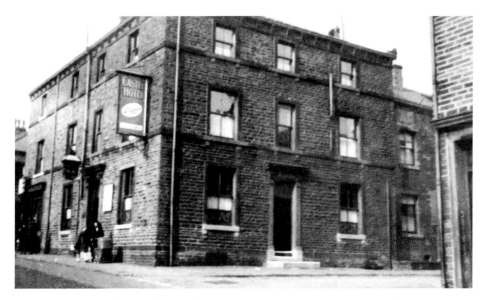

Whitaker's bought the Castle Hotel, Hanson Lane, an ex-Brear & Brown house, in 1916. That year Alfred Nebard was the landlord and sold specially labelled Irish whiskey carrying his own name and that of the Castle Hotel. When the Halifax Cattle Market used to be held at Victoria Road, the Castle Hotel had a special licence allowing them to open at ten o'clock in the morning for the farmers. In the early 1980s the pub was known as the Armada and then later renamed The Buccaneer before closing in 2009.

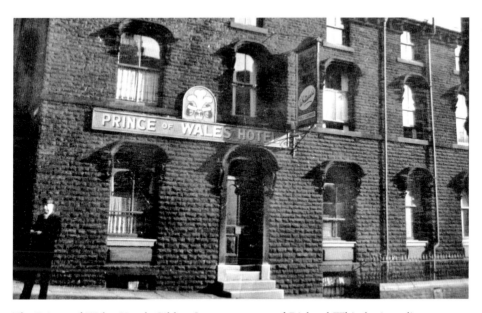

The Prince of Wales Hotel, Gibbet Street, was one of Richard Whitaker's earlier purpose-built public houses. It was erected around 1863 along with two cottages on the same plot of land. The weekly trade at the hotel in 1938 was six barrels and twenty-six dozen bottles. Following extensive refurbishments at an estimated cost of £1,500, trade increased in 1946 to eight barrels and thirty-six dozen bottles.

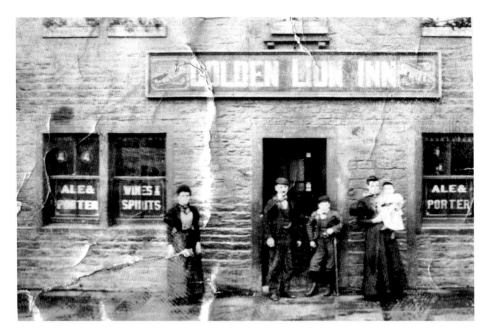

An old and rather battered photograph shows the original Golden Lion, Highroad Well, which dated from 1844 and stood much further out than its 1902 replacement; its building line was as far out as the Horse and Jockey Inn. The inn was demolished in 1901 for road improvements. The Highroad Well tram terminus was virtually located on the pub's doorstep.

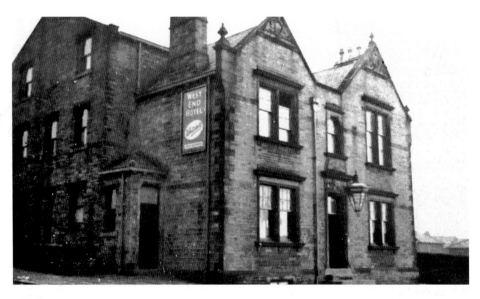

The West End Hotel, Parkinson Lane, designed by Petty & Ives, was purpose-built for Whitaker's. However, on completion in 1899, the justices refused Whitaker's request for a licence. Further refusals were to come over the next two years until, in October 1901, the hotel was granted a licence at the brewster session following an offer to surrender the licences of the Horse and Trumpet and the California beerhouse. This ended a 'dry' two-year period when the pub was run as a refreshment house, selling tea, coffee and soft drinks.

The sign on the gable end of Horsfall Street advertises the Bowling Green Inn. In 1929, an application was made to transfer the licence from the Bowling Green Inn to new premises that would be built on land adjacent to the pub, with the new inn to be known as the Big Six Inn – a name that regulars had known the Bowling Green Inn by for many years. Following debate, visits to the site and an adjournment for further consideration, the application was turned down by the justices and the licence for the existing premises was extended instead. In the write-up of the death of landlord George Horsfall in 1928, the pub was referred to as the 'silk-hat place', as he never allowed drunkenness and prohibited all games on the premises. Members of the female sex were never encouraged to frequent the house. The Big Six Inn was officially adopted as the pub's name in 1982.

This area has gone through substantial change, with most of the properties surrounding the Oddfellows, King Cross, demolished back in the 1970s. The Ramsden's sign has also long gone, following the company's takeover by Allied Breweries in 1964. The current Tetley's sign is much more informative, depicting various trades and crafts that made up the Order of Odd Fellows, whose members presumably once met at the pub.

A Ramsden's pub, the Shay Hotel, designed by Messrs Glendinning & Hanson of Halifax, opened in 1928 despite strong objections from Samuel Webster & Sons, who were looking after their own interest in the nearby Three Pigeons. The Shay Hotel received the transferred licence from the Cat I'th Window Inn and the licence of the Flying Horse was also surrendered as part of the agreement with the licensing authorities. The hotel is located at the bottom of Hunger Hill, below the Shay football ground, from where it takes its name and opposite what was the railway goods yard at Shaw Syke.

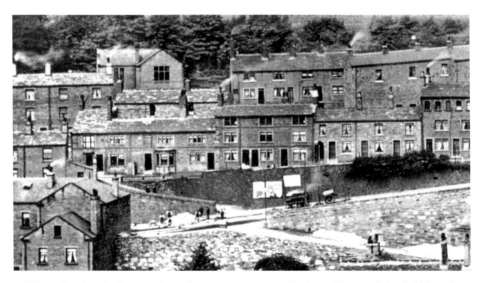

Old hostelry the Elephant and Castle gave its name to Elephant Terrace, Salterhebble, where it was located. It was at the inn, on 6 October 1735, that the famous scientist and maker of mathematical instruments Jesse Ramsden was born. It was also from this vantage point, in 1842, during the Plug Plot Riots, that thousands of protesters assembled and hurled stones at the cavalry returning from Elland, where they had been escorting prisoners to the railway station. The pub closed in 1932, its spirit licence being transferred to the Half Way House, Pellon.

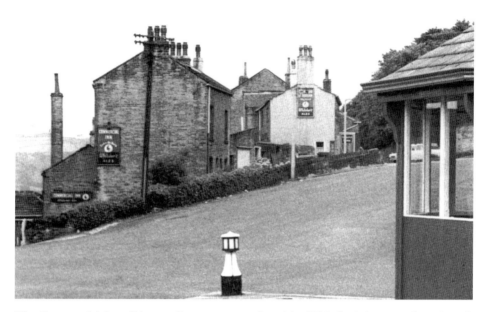

The Commercial Inn, Skircoat Green, was purchased by Whitaker's in 1897 from Joseph Naylor, along with five cottages, a lock-up shop, an outbuilding and a garden, for £2,400. The inn was located only a short distance from the Standard of Freedom, which was also bought by Whitaker's in 1897. The Commercial Inn closed in February 2004 and the building later became Katelans, a wine bar, before finally closing as licensed premises in 2007.

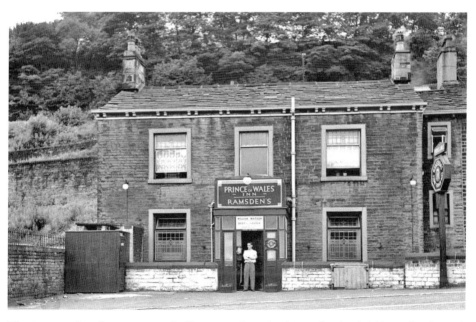

The Prince of Wales Inn was ideally situated at the base of Salterhebble Hill. The pub opened in 1897. William Watson was the landlord when this photograph, showing the pub in its Ramsden's days, was taken. The Prince of Wales Inn closed in 1962; two years before, Ramsden's was taken over by Allied Breweries.

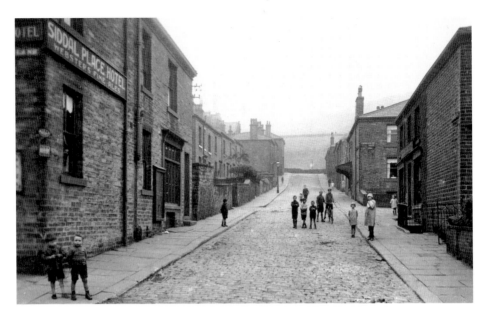

Two young lads stand outside the Siddal Place Hotel on the corner of Oxford Lane and Siddal Street. The Siddal Place Hotel was purchased by Webster's in December 1890. The Siddal Place is still operating, unlike many other pubs in the area such as the Rose and Crown Inn, which was located at 13 Siddal Street, in the block beyond the canopy of Farrar's butcher's, on the right.

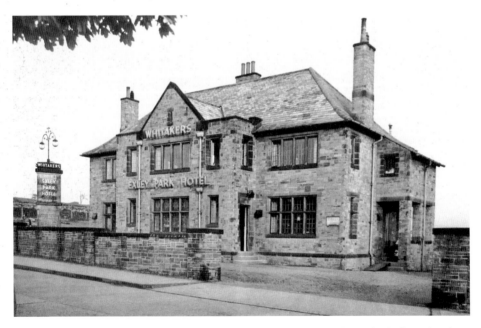

Designed by Walsh, Maddock & Wilkinson, the Exley Park Hotel was built for Whitaker's in 1939 at a cost of just over £7,000. The pub is situated on Park Lane near to where the Halifax Zoo and Amusement Park opened in 1909; however, Park Lane predates this by at least sixty years. The lane then led to Park Gate, Park Nook and, further on, Elland Park.

3

North of Halifax

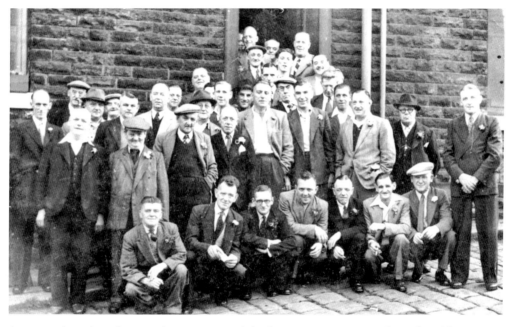

A group of regulars about to depart on one of the frequent race trips run from the Old Lane Inn, Halifax. The inn had been purchased by Webster's in around 1872 and continued to trade until 1962. After being closed for twenty years the pub was reopened, as a free house, in 1982. In 1994, the pub was put up for sale, along with the four back-to-back cottages that were located on the top of the inn.

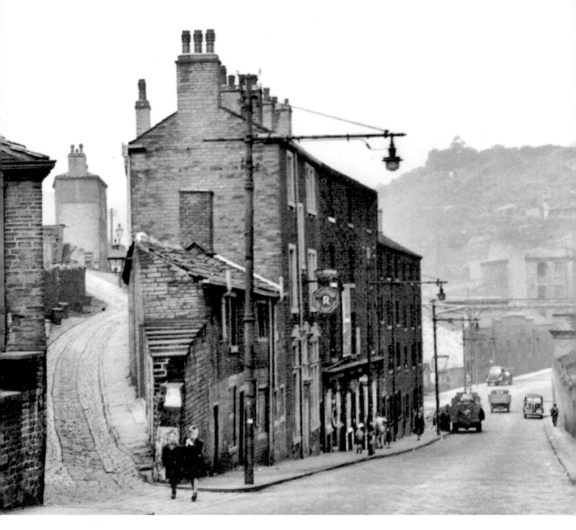

With the mills at Dean Clough, the area around Lee Bridge had plenty of options for the thirsty worker. The Ramsden's sign on the left is for the Lee Bridge Tavern, known locally as 'the Spinners'. Other pubs in the immediate vicinity were the Angel Inn, the New Inn and the Shears Inn. The last landlord of the Lee Bridge Tavern was Ernest Proctor, who, when the pub closed at the end of 1954, took over the Mount Inn on Commercial Road.

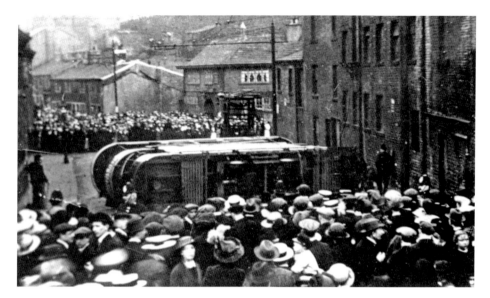

On Saturday 22 May 1915, the Shears Inn, Lee Bridge, was witness to one of the several tram accidents that occurred in Halifax. Tramcar 89, heading towards Halifax with a full car as it was Whit Saturday, turned over for no apparent reason, doing only 4 mph; fortunately there were no fatalities, but the evening incident attracted crowds of hundreds, no doubt including many Shears customers.

The Shears Inn goes back to at least the early nineteenth century, Joshua Keighley being the landlord between 1822 and 1837. The present building dates from 1904. The pub can be seen beneath the pipes linking Crossley's Dean Clough Mills – perhaps an indication of the more permanent topping it would receive in the 1970s, when the new flyover to Ovenden was built directly above the inn. In 1987, the pub was renamed the Dean Clough Inn; it now operates as the Olde Shears Inn.

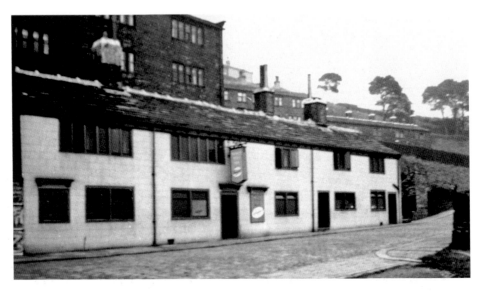

Made from a row of weavers' cottages, the Wheatley Wells was an ex-Brear & Brown pub purchased by Whitaker's in 1916. Customers who visited the pub in more recent years would have found it surrounded by trees – slightly different to this 1939 photograph. The pub at one time would have had many customers from the multi-storey 'top and bottom' houses that were plentiful around the Ramsden Street and Wheatley Road areas. The Wheatley Wells Inn closed in 2009.

A horse-drawn cart is stopped outside the Crown and Anchor Inn in this view of Mixenden. Herbert Seston was the pub's best-known landlord – he became the real-life Doc Shire, an advertising figure designed for Whitaker's by J. J. Mulroy. Dressed in his top hat and tails, he would attend galas and fêtes and was regularly seen at rugby matches, including the 1931 Challenge Cup Final when Halifax beat York 22–8.

Samuel Webster acquired the Fountain Head Brewery, Ovenden Wood, in 1838. Seven years later, he set out to expand his business by purchasing pubs that would become tied to his brewery; his first pub was the Lane Ends at Wheatley, bought in 1845.

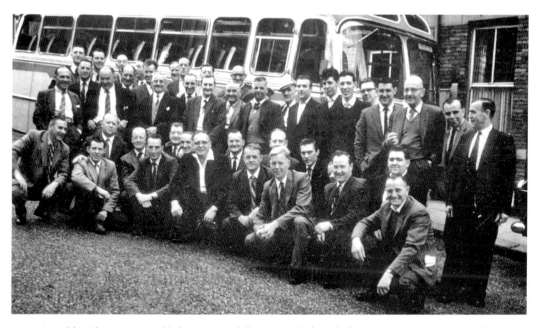

Arnold Holmes is second left on the middle row, with friends from the Lane Ends, Wheatley, ready for one of their regular trips in 1961. In 1966, Webster's built the nearby Sporting Life and on 2 February 1966, the licence from the Lane Ends was transferred to the new pub and Webster's first pub was closed. The Sporting Life was renamed Macmillan's in December 1983.

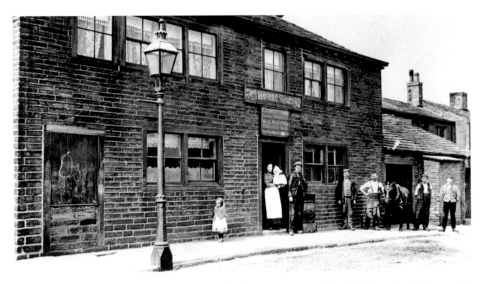

The Three Horseshoes was located at Clough Lane, Mixenden. The landlord when this photograph was taken was George Lumb, who was also the blacksmith. It was in his forge, on the morning of 28 February 1906, that he was found hanged. An inquest was held at the Shoulder of Mutton Inn, Mixenden, where a verdict of 'suicide while of unsound mind' was agreed. The beerhouse closed in 1914 due to a reduction in clientele – another impact of the First World War.

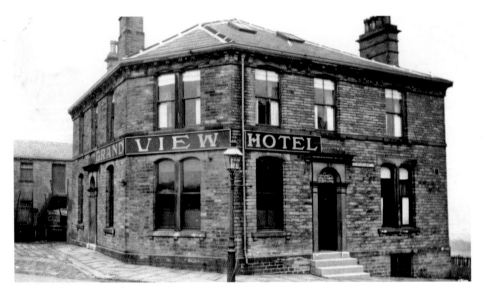

In April 1903, the inquest into the death of eighty-year-old Mary Walsh took place at the Grand View Hotel. Mrs Walsh had been cleaning her outside step when a sudden gust of wind caused a ladder being used next door to fall and hit her head. The injuries sustained proved to be fatal; the verdict was accidental death. The Grand View became a Webster's pub in 1877, when the company bought the Albert Springs Brewery and its tied houses. Although the pub is now closed, one of the famous Webster's black cats remained standing on the roof of the building until at least 2009.

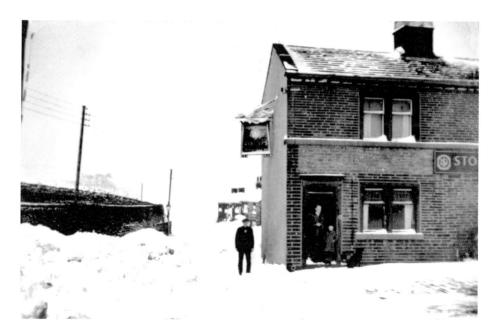

The end of the first week of snow in 1947 at the Stone Chair Inn, Mixenden. The ice and snow had, on day two, brought down the telegraph lines that ran down the right-hand side of Moor End Road, although those on the left appear to have survived. The pub was fortunate that the wind swept across rather than directly at the building; it therefore avoided some of the drifts that reached the bedroom windows of some of the houses in the background.

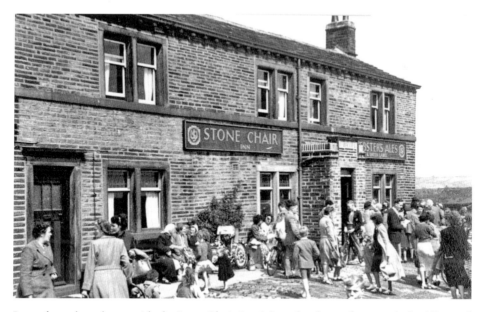

Lots of people gather outside the Stone Chair Inn, Mixenden, but unfortunately for Allan and Renee (Irene) Rusby, the landlord and landlady at the time, there is not a single glass in sight. The occasion was the 1949 gala, with the crowd preparing for the procession to Mixenden. The Stone Chair was one of Webster's earlier purchases, bought by the brewery in 1866.

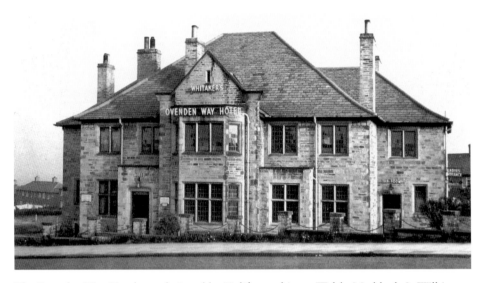

The Ovenden Way Hotel was designed by Halifax architects Walsh, Maddock & Wilkinson. The pub was built for Whitaker's brewery in 1938, at a cost of approximately £8,000. In this photograph, entrances can be seen for the hotel and the tap room. On the right is the ladies' entrance. In a 1939 inventory, the hotel had a tap room, smoke room, bar lounge, music room and ladies' room.

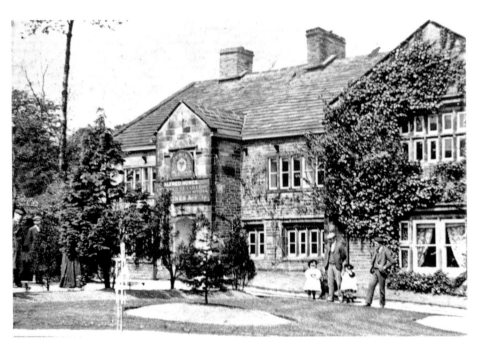

Spring Lea, Ovenden, is a Grade II-listed building that dates back to the early part of the seventeenth century. In around 1870, the grounds were made into pleasure gardens – named Wright's Gardens after their owner – and part of the house was converted into a pub. Alfred Howes was landlord of the Spring Gardens when this photograph was taken in around 1890. The pub closed in 1919.

Located opposite the end of Shay Lane, Webster's Ovenden Cross Inn can be seen on the left in this photograph taken in 1957. The Halifax Choral Society held its first meeting at the Ovenden Cross Inn in 1818 and few would have foreseen that, almost 200 years later, they would hold the distinction of being the world's oldest choral society with an unbroken run of performances.

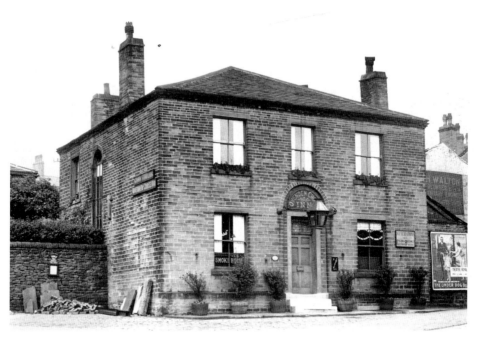

In April 1903, Charles Barty was taken into the Ovenden Cross Inn after falling from his horse-drawn wagon, which witnesses said was going at great speed. He died there shortly afterwards. In a photograph taken in Joseph Stock's day, a sign shows that alterations were being carried out by Fielding & Bottomley of Halifax. To the left of the pub is a timetable for the Hebble bus service.

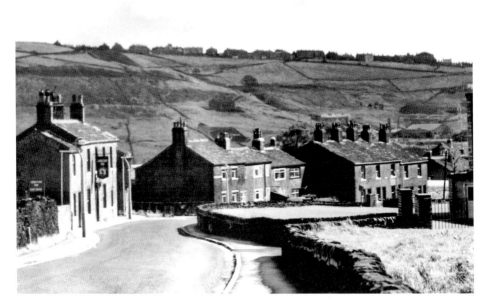

The Junction Inn is located at the junction of Moor Bottom Road, Holdsworth Road and Riley Lane, Holmfield. The sign clearly shows the pub was a Whitaker's house at the time this photograph was taken.

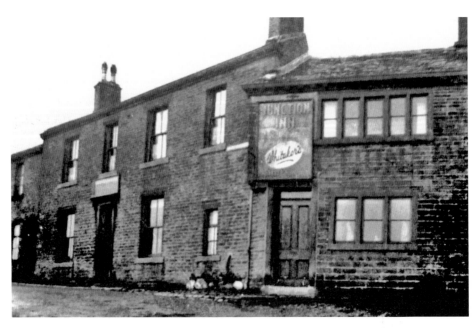

In 1937, when this photograph was taken, the Junction Inn had a beer-and-wine-only licence, with a trade of one barrel and six dozen bottles a week. Its main opposition in the area was the White Swan Inn, located slightly further down Holdsworth Lane, which had a full licence. Following improvements by Whitaker's, trade increased in 1946 to two barrels and seventeen dozen bottles per week.

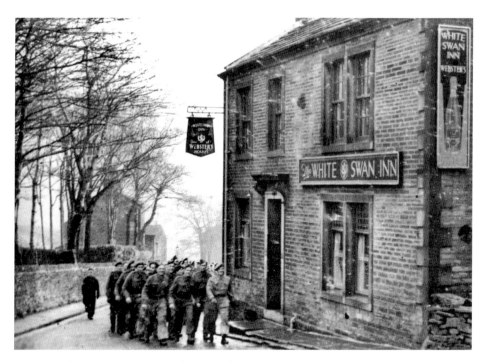

A group of soldiers marches swiftly past the White Swan Inn, Holmfield. The pub, which first opened in 1759, was purchased by Webster's in 1878 from J. Henry Wadsworth. It closed in August 1971.

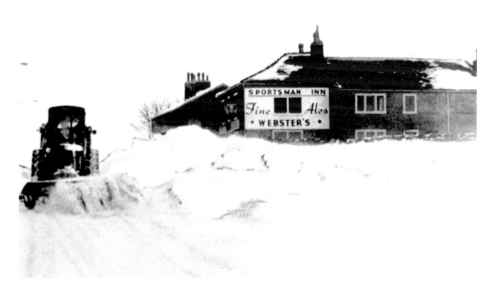

It took a tremendous effort to keep Keighley Road, Illingworth, clear but few customers would have ventured out to the Sportsman Inn during the great snow of 1963. The pub was a Joseph Stocks house until Webster's acquired the Shibden Head Brewery. It wasn't until 1965 that the old beerhouse obtained a full licence.

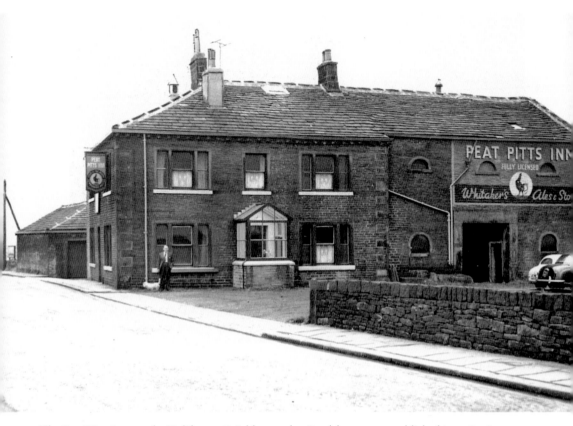

The Peat Pitts Inn, on the Halifax-to-Keighley road at Bradshaw, was established in 1789. In 1923 the pub became a Whitaker's house, as seen in this 1957 photograph. It transferred to Whitbread following the company's takeover of Whitaker's brewery in 1968. Whitaker's used to advertise the pub as having 'catering, a miniature golf course and bowling green'. In 1984 the pub was sold by the brewery for £91,000 and became a free house. Following substantial rebuilding, it reopened as the Moorlands Inn.

The Grey Horse was located at Soil Hill, Holmfield. This photograph dates from when the pub was owned by Joseph Stocks Brewery, prior to it being transferred to Webster's when they took over Stocks, in 1933. The Grey Horse closed in January 1941.

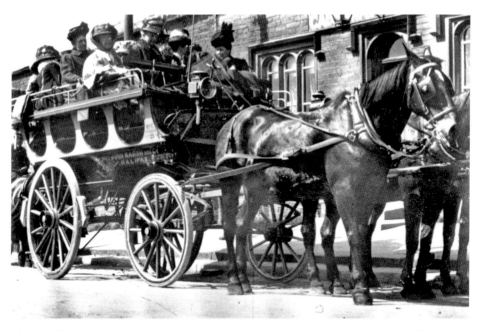

These ladies, on a horse-drawn charabanc belonging to John Marsh of Halifax, have presumably stopped at the Causeway Foot Inn for refreshments prior to heading to Ogden. John Marsh was landlord of the Royal Hotel, Sowerby Bridge, and founded his cab business in the middle of the nineteenth century, and later purchased the established omnibus business of C. Ramsden in 1885. On 4 July 1900, at the Plummet Line Hotel in Halifax, the stables and property of John Marsh were sold at auction, by order of the High Court of Justice, at prices the auctioneer described as 'a sacrifice and a slaughter'.

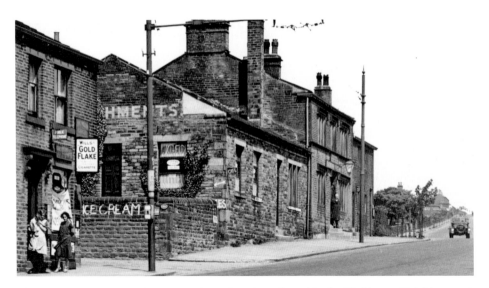

The Causeway Foot Inn, in its prominent location alongside the Halifax-to-Keighley road, has served travellers for many years; it is probably older than the 1753 Halifax and Keighley Trust Act for repairing the road. The inn has been long established as a stopping place for those wishing to explore the surrounding countryside and even now is advertised as 'the gateway to Ogden Water'.

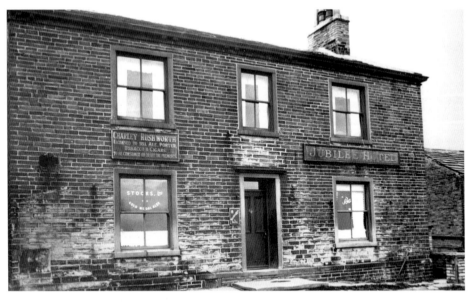

The Jubilee Hotel, known originally as 'The Rock' – presumably due to the many quarries in the area – was located at New Street, Southowram. In fact, several of its early landlords doubled as 'delvers' or quarrymen. The pub changed its name in 1887 to celebrate the Golden Jubilee of Queen Victoria. The landlord when this photograph was taken was Charley Rushworth, who was only licensed to sell ale and porter as the beerhouse did not get a full licence until 1961. Jack Wilson, who played for Halifax RLFC, was the landlord before Bert and Mary Habergham took over in 1956.

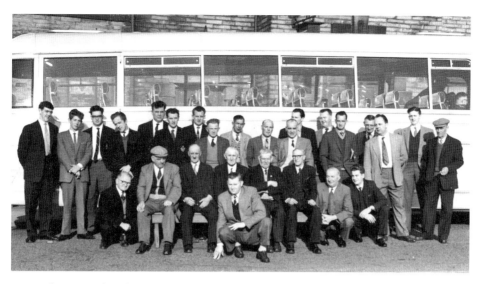

Bert and Mary Habergham kept the Jubilee Hotel until 1971. Bert can be seen seventh from the left on the back row in this picture, taken during one of the Jubilee Hotel's annual trips. The photograph dates from around 1960 and, due to the difficulty of getting a coach down New Street, was taken outside the club at Southowram. After leaving the Jubilee Hotel, Mary went on to work at the White Swan, Halifax, in the cocktail bar and, for many years, in the 'Dutch Bar'. The Jubilee closed in the early 1990s and was sold by Belhaven in 1994; the property is now a day nursery.

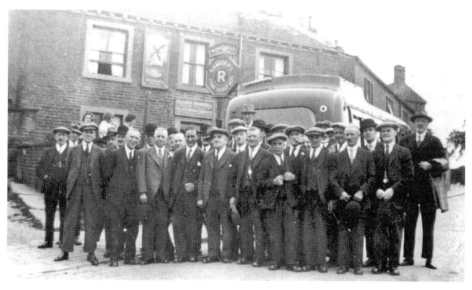

Bowler hats appear fairly popular with the gentlemen of Northowram, who are ready for the off outside the Windmill Tavern. It was in premises behind the pub that James Alderson moved his brewery from Lower Brear; he established the Windmill Hill Brewery in 1899. At the time of the trip, Elijah Trudgill was landlord, which dates the photograph to the 1930s; it was possibly a trip to see the Rugby League Challenge Cup Final at Wembley in 1939, when Halifax beat Salford 20–3.

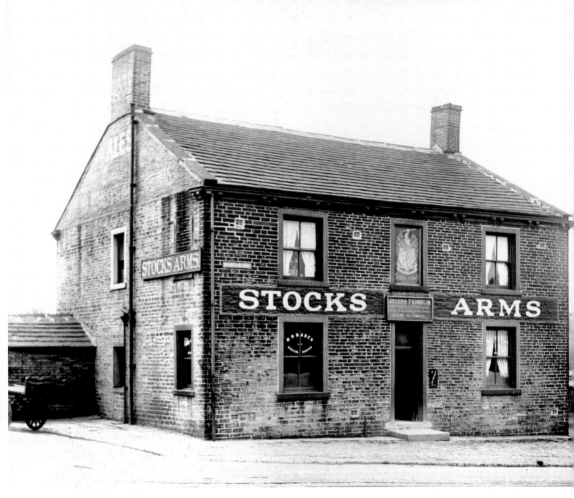

Joseph Franklin was the landlord of the Stocks Arms, Northowram, when this photograph was taken in around 1917. The inn sign is clearly a coat of arms for the Stocks family. For some unknown reason, a more recent sign showed a violinist with only one leg in a set of stocks. In 1837, the family owned six of the twenty-three licensed houses in the Northowram township. The Stocks Arms closed in 2009 and the building has since been converted into an Italian restaurant.

4

Brighouse and Surrounding Areas

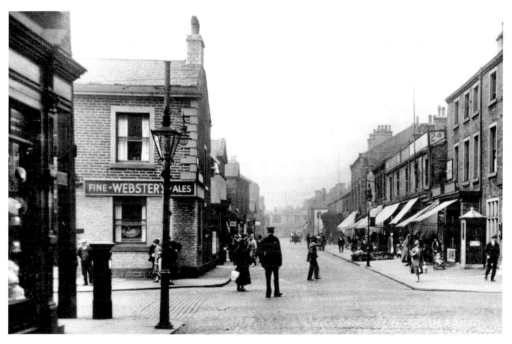

The White Swan, Brighouse, was located on the opposite corner of Commercial Street to the George Hotel. The pub became a Webster's house in 1877, when it was bought by the brewery from William Monks. In 1904, police objected to the renewal of the White Swan licence, along with nine other Brighouse inns, as the publicans habitually employed female musicians. The justices, however, allowed all the licences to be renewed on the understanding that no female vocalist should be engaged, as well as no female pianist under the age of twenty-one.

The murder of Lord Cavendish in Phoenix Park, Dublin, on 6 May 1882 led to serious rioting in Brighouse. Lord Cavendish, the Parliamentary representative for the Northern West Riding of Yorkshire, which included Brighouse, had visited the town many times and was held in high esteem. Although the police anticipated a backlash against the Irish, they were not prepared for the scale of the riots that occurred throughout the town. The initial attack took place at Taylor's Yard, known as 'Zingo Nick', an area where there were many Irish lodgers. Windows were smashed and when the mob came across an Irishman, he was beaten, sometimes very severely. A few months earlier, at the Bradford court case against Tobin, a member of the outlawed Fenian movement, it had been highlighted that some thirty-five Irishmen in Brighouse were paid-up members of the movement. The mob, between 3,000 and 4,000 strong, proceeded through the town, leaving a trail of destruction and carrying out further beatings while heading towards the Sun Dial Inn, where it was believed the movement held its secret meetings. At the Sun Dial Inn, then run by Irishman William Lawlor, the mob demanded that all the Irishmen be turned out. Fortunately there were only a few Irish lodgers present, but they received rough treatment. One Patrick Jordan, who had hidden under a bed, was thrown down the stairs and savagely beaten. The forty or fifty rioters who had entered the inn then ransacked it, smashing the bar door and stealing the takings, bottles of ale, tobacco and cigars.

On the second evening the rioters again headed to the Sun Dial Inn, but a small force of constables had assembled in the area and prevented any further damage. However, the mob went on to cause considerable damage to St Joseph's Roman Catholic Church and at one point virtually

laid siege to the police station. The following evening, with substantial reinforcements from Halifax, Huddersfield, Barnsley, Bradford and many other towns, the police were clearly in no mood to allow the disturbances to continue. Over 200 officers, armed with cutlasses and batons, gave out beatings to the rioters and innocent bystanders, including women and children, who had ventured out to watch. Brighouse returned to normal, but retribution, revenge and 'hard labour' for some of the rioters went on for many months. Many of the Irish labourers left Brighouse and were never seen again. However, William Lawlor remained and continued to serve at the Sun Dial Inn, seen here advertising John Smith's Tadcaster Ales before its closure in 1909.

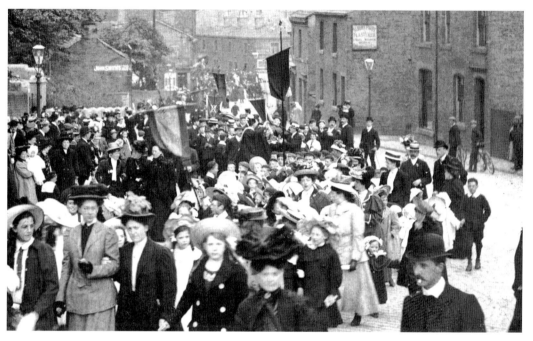

A bit more peaceful than the riots of 1882, this procession of the Brighouse Church Sunday School passes the Sun Dial Inn in around 1905.

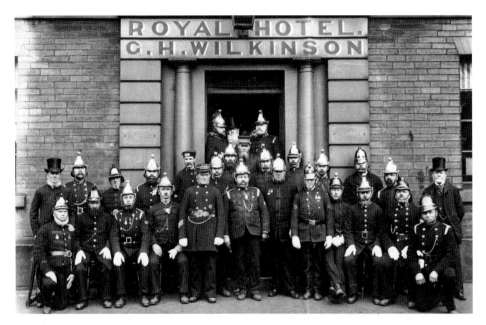

Taken in 1890, this photograph shows officers of the West Yorkshire Fire Brigade outside the Royal Hotel, Brighouse. During the 1882 Irish Riots, many of the injured were treated at the hotel. The number and severity of the injuries was considerable. One Mary Moody had such severe injuries that it required six leeches to her temple to relieve the pressure built up over an eye wound. The hotel closed in 1970 and was demolished three years later.

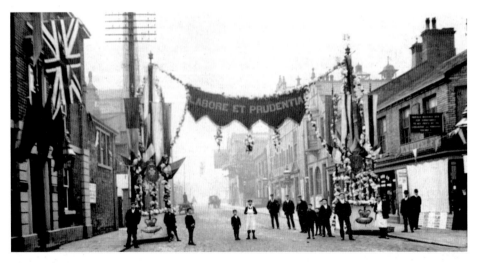

Flags fly from the Royal Hotel, Huddersfield Road, and a large banner bears the motto of Brighouse Borough Council, 'Labore Et Prudentia' ('By labour and prudence'). The occasion was the visit of HRH Princess Louise, the daughter of Queen Victoria, to open the Smith Art Gallery on 22 May 1907. The Royal Hotel was one of Brighouse's principal hotels. In J. Horsfall Turner's The History of Brighouse, Raistrick and Hipperholme there is an example of a bill poster advertising the Great Court Leet to be held at the Royal Hotel, Brighouse, on 6 May 1873.

In 1997, Alan Jones, in his excellent column in the *Halifax Courier*, 'View from the Snug', referred to an entry he had read in an 1873 diary: 'Last evening I took a walk as far as Brighouse with a friend. We saw a public house called the Staff of Life, if they had put the Staff of Death it would have been nearer the truth.' Not a very good review for the pub. However, the following year, when a new set of bells was installed in St Martin's Parish Church, the Staff's name was changed to the Ring O'Bells. The pub continued to operate until the 1960s, when it was demolished to make way for the Wellington Arcade Development.

The Round House Inn came into existence shortly after the Beerhouse Act of 1830, being one of 30,000 new beerhouses that opened within two years of the act being passed; at least ten were in the Brighouse area. In an 1898 deed of conveyance, the pub is referred to as the 'Roundabout House or Oddfellows Arms'. In 1946, the police objected to the renewal of the Round House licence and it was referred. However, renewal of the licence was nevertheless granted and the pub survived until its final closure in 2000.

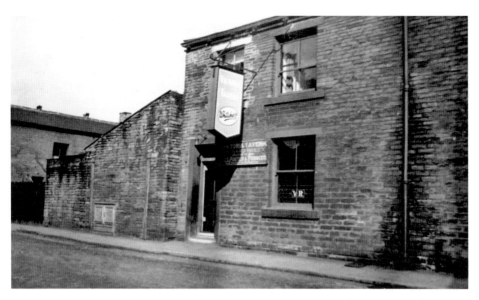

In 1939, the Victoria Tavern, Mill Lane, was leased by Whitaker's from Mellor's of Brighouse. The brewery eventually bought the pub in 1955 and it was still with the brewery when it was taken over by Whitbread in 1968. However, in 1975 it is recorded that the pub had reopened, after temporary closure, as a free house. At the Brighouse Brewster Session of 1939, it was recorded that the magistrates had been referring the Victoria Tavern since 1910, but the bench continued to renew its licence and stated it would continue to do so if referred again. The pub is now known as The Barge.

Thirsty work. The cart is full and the man on the right holding his hand to his nose indicates what with. Occupying a prominent position in the background is the Commercial Inn, Brighouse. The inn was sold at auction in 1868, along with the Railway Brewery, later known as the Red Cross Brewery. It then became a Joseph Stocks house before transferring to Webster's when the company took over the business in 1933.

Looking down on Brookfoot from its elevated position, the Neptune Inn opened in 1822 near the bottom of Brookfoot Lane. In 1889, the pub was put up for auction along with several other lots, including the Grove Inn, as part of the sale of the Freeman's Estate. The pub was sold to Thomas Ramsden for £630. The Neptune Inn closed in 1930.

In 1898, Sir George Armytage of Kirklees offered the Black Horse Inn, Clifton, to Whitaker's for lease, along with the Pack Horse and the Black Bull. The overall yearly rental was £360, the Black Horse Inn being £100 per annum. Whitaker's continued to renew the lease yearly, despite the three pubs in question giving them a £13 7s loss in 1903. The brewery continued to accept this until it eventually negotiated a discount with Sir George.

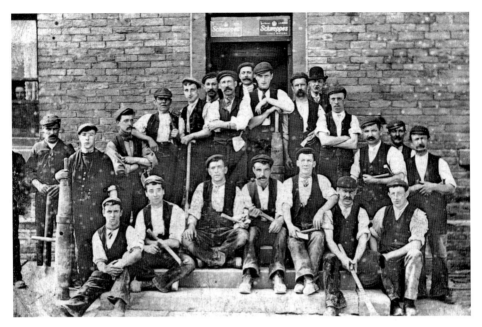

These men on the steps of the Martins Nest pub have worked up a thirst laying the new tram track along Bradford Road, Brighouse, in 1904. It is difficult to say whether they have just 'slaked their thirst' or are ready to enter the pub. The lack of smiles suggests someone is holding them back from their beer. The Martins Nest was another Brighouse pub that opened shortly after the 1830 Beerhouse Act and provided travellers on the Bradford-to-Huddersfield turnpike with a welcome stop.

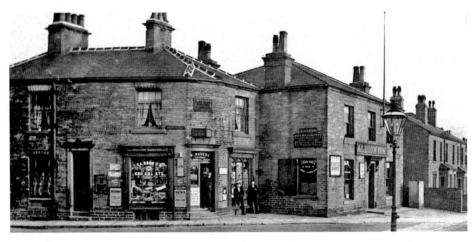

John William Fawcett was the landlord of the Albion Inn, Brighouse, when this photograph was taken in around 1901. The Albion Inn, a Ramsden's house, was converted into a restaurant in 2007. It was near here, at Lane Head, that the sons of Sir Robert Beaumont, Hugh De Quarmby and John De Lockwood waylaid Sir John Eland and murdered him before proceeding to Elland. Here they slew Sir John Eland, Jr, and his infant son, wiping out the Eland line in revenge for the murder of each of their own fathers by Sir John Eland in 1341.

The original Dumb Mill Inn was located alongside the ancient pack horse route out of Halifax heading east. Following a 1741 Act of Parliament, a new turnpike was created, bypassing the original inn, so a second Dumb Mill Inn was built in around 1754 beside what is now Halifax Old Road. The road was again rerouted in 1833, prompting yet another inn to be built, known as the New Dumb Mill Inn, now The Country House. The second inn, seen here in the shadows of the Brear & Brown Brewery, became the Old Dumb Mill Inn, and served customers until its closure in 1937.

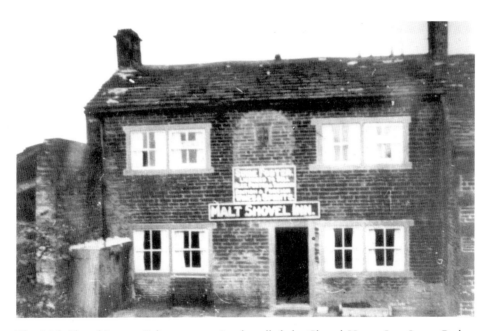

The Malt Shovel Inn at Coley was previously called the Chapel House Inn. James Parker wrote in his *Illustrated History of Wibsey, Low Moor, Oakenshaw, Wike, Norwood Green, Judy Brig, Royds Hall, Coley and Shelf* that on 24 January 1902 the inn sign had been taken down for repainting and had revealed an object of great interest at the front of the ancient hostelry. Behind the sign, built into the wall, was the ancient double cross of the Knights of St John of Jerusalem, dated 1647. The cross can just be seen above the sign in this photograph. Unfortunately, despite its antiquity and historical importance, the building was demolished in 1970.

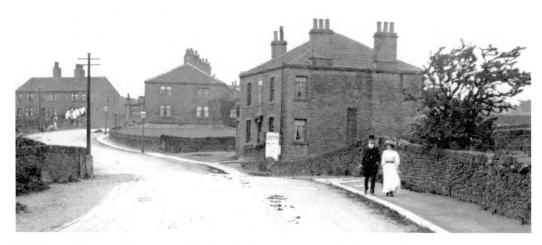

The Brown Horse at Coley was originally a beerhouse, and was listed as such in 1905, when Isaac Wheatley was the landlord. The pub obtained a full licence in April 1949. The present building was erected in around 1800 and is thought to have replaced an even earlier inn.

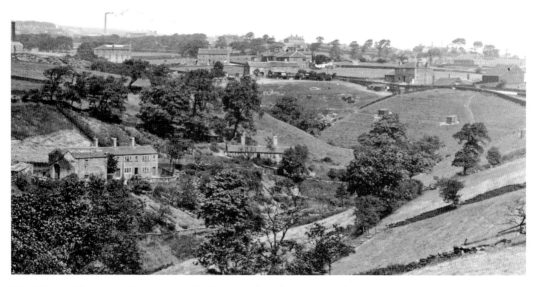

The Brown Horse can be seen overlooking Bird Holme, alongside the Brighouse-to-Denholme Gate road. In 1933, the Brown Horse, like many other Joseph Stocks houses, was transferred to Webster's when the company bought the Shibden Head Brewery at Ambler Thorn.

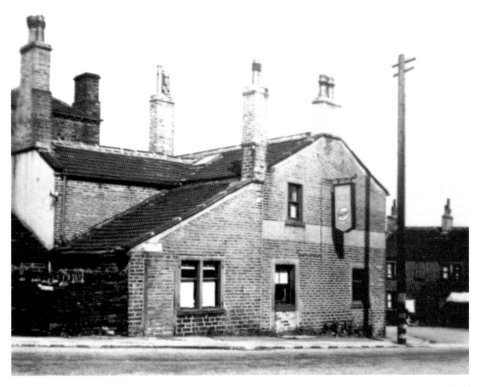

Dating from the early nineteenth century, the Duke of York is located at Stone Chair, Shelf – an area named after the unique 'Stone Chair' guide post, which has provided directions and a useful resting place since 1737.

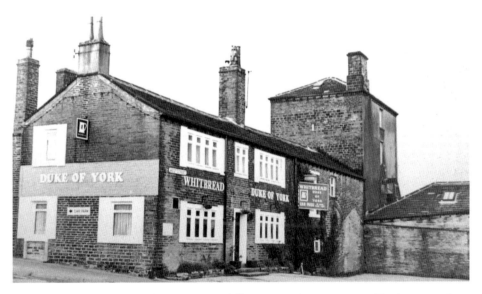

It was at the Duke of York that James Sutcliffe ran West Street Brewery. The brewery, along with the pub, was sold to Brear & Brown of Hipperholme in 1891. The pub was taken over by Whitaker's in 1916 and subsequently Whitbread in 1968.

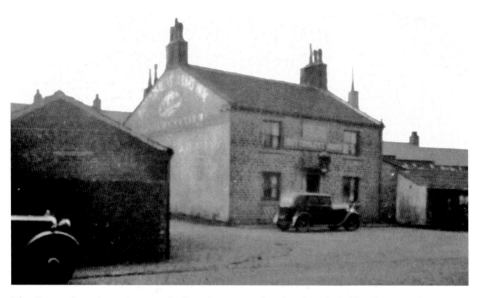

The Bottomleys Arms is named after the Bottomley family of Shelf, who moved into the area in the eighteenth century and went on to build many properties, including Wade House, Shelf Hall and Victoria Mills. The pub was purchased by Whitaker's brewery in 1889, along with its barn, stables and blacksmith shop. In March 1899, the then landlady Mrs Stead was given notice to quit by Whitaker's, 'very bad reports having been laid before the Board respecting the conduct at the Bottomleys Arms'.

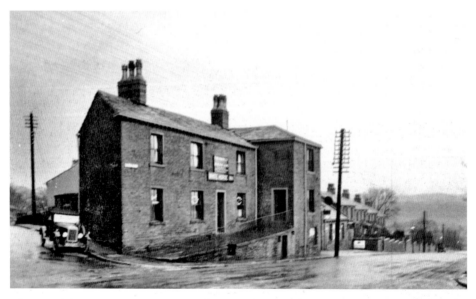

This view of the White Horse Inn, Lightcliffe, was taken from Knowle Top Road, where a tollgate once operated across the then not quite as busy Leeds-to-Whitehall turnpike road. The White Horse was owned by Joseph Stocks's Shibden Head Brewery until 1933, when the brewery and its tied houses were purchased by Webster's Brewery.

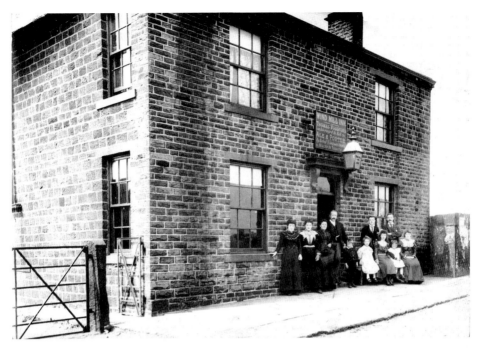

The Windmill at Shelf was built by John Sugden at Witchfield Hill in 1789. The Wind Mill Inn in Stannage Lane was built over a hundred years later, in 1897. Here we see, presumably, landlord Thomas Woodford and family. On the right, the stone blocks denote that common feature of pubs in those days, the gentlemen's outside toilet.

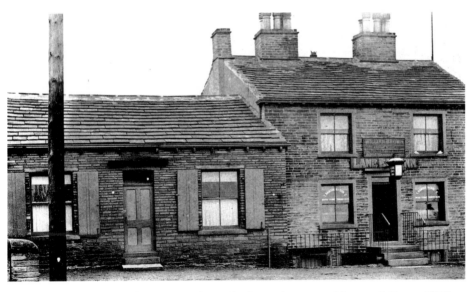

The Lane Ends Inn was located at the end of Sowden Lane, Norwood Green. William Brown was the landlord when this photograph was taken. By 1905, Mrs H. Brown had taken over as the landlady. The signage in the window advertises 'T. Ramsden & Son, Noted Stone Trough Ales'. The pub closed in 1955 and is now a private residence.

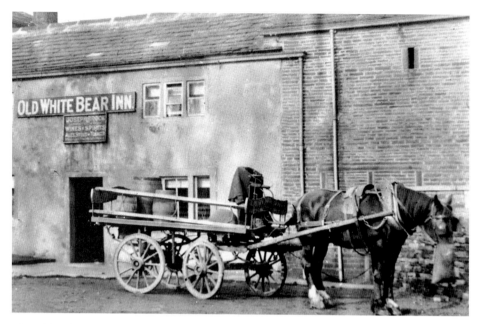

The Old White Beare, Norwood Green, dates from the mid-eighteenth century and is named after a ship bearing the name *White Bear* that fought against the Spanish Armada in 1588 under the command of Edmund Sheffield. The forty-gun ship, one of the great ships of the Royal Navy, was capable of carrying 300 mariners, forty gunners and 150 soldiers. The ship was broken up and rebuilt in 1598–99.

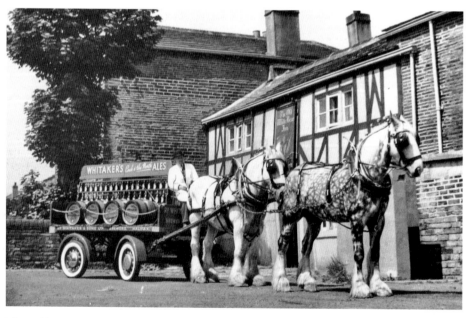

The Old White Bear Inn was bought at auction by Whitaker's in 1892 from the Low Moor Company, along with its stables, brew house and piggeries. In 1907, a number of outbuildings were demolished and further piggeries were built at a cost of £100.

The Greyhound Inn was one of the last pubs purchased by Richard Whitaker & Sons prior to the brewery becoming a limited company in 1890. Whitaker's bought the pub – which is located on Crowtrees Lane, Rastrick – in 1889. In the 1940s, the brewery made alterations to the pub, as both sexes had to walk a considerable distance to the outside toilets.

Joseph Carter sold the Sun Inn, Rastrick, along with three cottages and the George and Dragon Inn, Elland, to Whitaker's brewery in 1896 for £4,300. At the time of the sale, the Sun Inn had a coach house, stables and privies, which were located at the back of the rear yard. In the 1890s, the Brighouse Lark Singing Association held contests at various pubs around the town, including the Sun Inn.

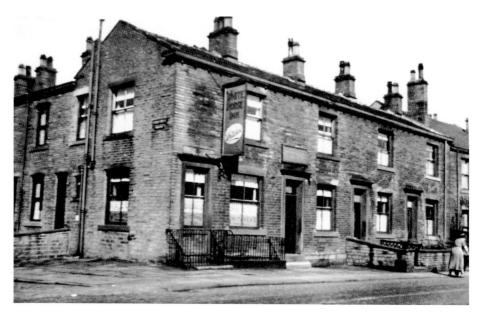

The White Horse was built on a close of land called Upper Pickering, bounded by Rastrick Common and Brook Street, along with twelve cottages, a stable and outside conveniences; all were bought by Whitaker's brewery in 1869. Sarah Shaw was the landlady when this photograph was taken in the 1930s. The pub closed in December 2009 and was put up for sale by Enterprise Inns with an asking price of £70,000. An application was subsequently approved, in 2011, to convert the inn into a private dwelling.

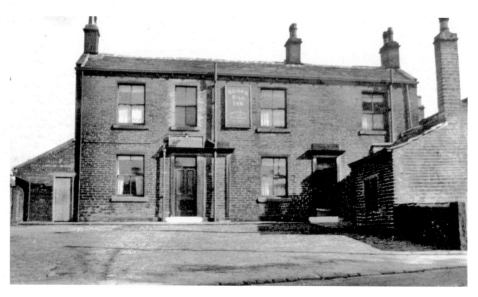

Named after the well-known hill overlooking the pub, the Round Hill Inn, Rastrick, was a Whitaker's pub when this photograph was taken in the 1930s, the brewery having bought the pub in 1896 for £475. No doubt customers will have participated in the ox roast that celebrated the Coronation of George V at Round Hill – which was also where a large bonfire celebrated the King's Silver Jubilee twenty-five years later.

5

Elland and Surrounding Districts

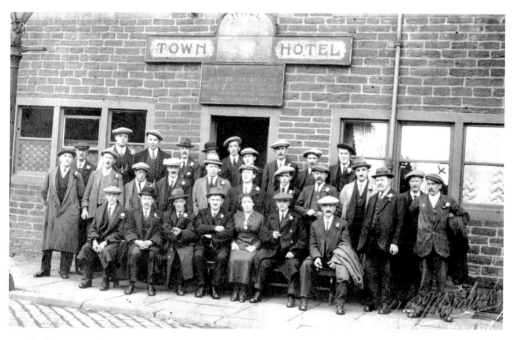

Ready for a trip, these gents are outside the Town Hall Hotel, Huddersfield Road. Presumably the lady in the picture was Florrie Pearson, the landlady of the pub at the time. Joseph Blackburn was landlord of the beerhouse when the nearby Elland Town Hall was opened in 1888 and he saw the pub renamed shortly afterwards, to reflect its close proximity to the new building.

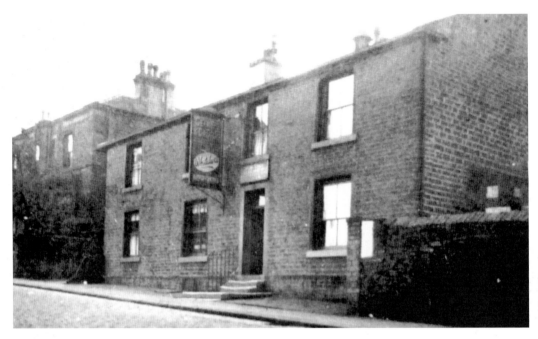

The George and Dragon Inn, Elland, was built by Thomas Casson on a close of land known as the Sheep Croft. Together with the Sun Inn, Rastrick, and three cottages, the inn was sold in 1896 for £4,300 by Joseph Carter to Whitaker's brewery. The inn operated under the name of Old Bailey for several years until its closure. In February 2011, the premises were displaying 'for sale' boards.

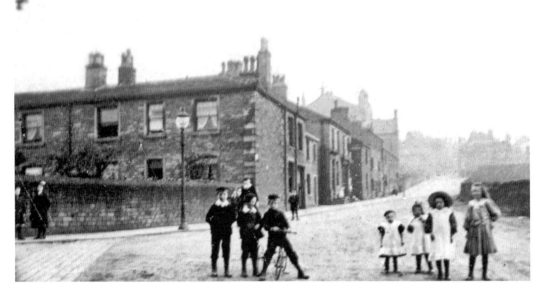

These children are standing in the middle of Eastgate, Elland. Behind them is the Ivy Inn, a beerhouse, where George Halstead was the landlord when this photograph was taken in around 1905. The Ivy Inn, which was created from four cottages in around 1890, closed in 1910 due to redundancy. With six other licensed premises within 300 yards, the pub was selling less than a barrel a week.

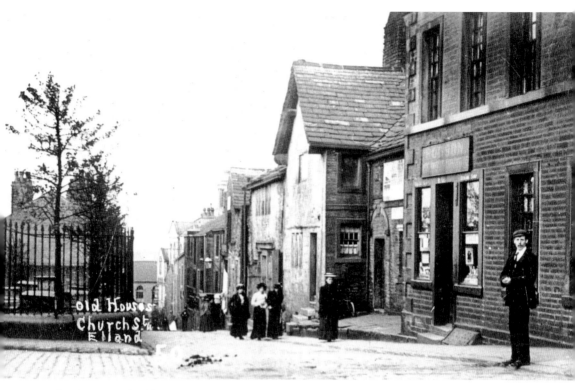

The distinctive building with the large gable end on the right of Church Street, Elland, was the Red Lion Inn; its coaching house was immediately below. The Red Lion, now demolished, was a timber building faced in stone. It was from here in 1822 that the *Royal Fleece* coach departed at 4 p.m. each Sunday, Tuesday and Thursday en route to Halifax. On Mondays, Wednesdays and Fridays it would leave at 9.30 a.m. for Sheffield. Another coach, the *Hark Forward*, left from the inn each day except Sunday, bound for Wakefield. Every evening it ran to Halifax at 7 p.m.

In 1774, landlord Ely Dyson placed an advertisement regarding his business as follows: 'Ely Dyson, At the Red Lion Inn, in Elland, begs leave to acquaint Gentlemen, Tradesmen and Others, that he has fitted up a Genteel Post Chaise, with Good Horses and Drivers, at Nine pence a Mile. Those who are pleased to oblige him with their Favours will be gratefully acknowledged by Their Most Obedient and Humble Servant, E. Dyson.'

In 1783, the landlord's daughter died during childbirth. Following the last rites given by the minister at Elland Church, opposite the pub, an argument broke out between the landlord and a past suitor of his daughter. Following a previous argument with the landlord, the suitor had run off and joined the army. Perhaps unwisely, the landlord struck the soldier at his daughter's graveside and there followed a fight. Blood led all the way from the church into the Red Lion – the landlord was said to have received a 'good-hiding' for his initial blow.

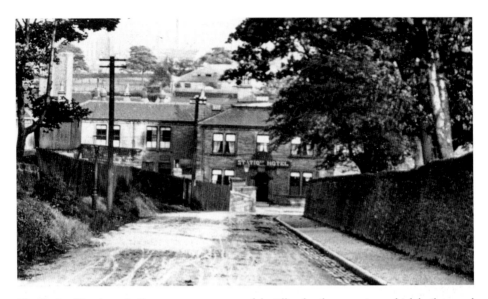

The Station Hotel was built to serve passengers of the Elland railway station, which had opened in 1842; the hotel dates from the early 1880s. Some of the railway station's first passengers would have been the Plug Plot rioters, who were captured in Halifax in August 1842 and brought to the station, guarded by horse soldiers, on their way to Wakefield Prison.

In 1916 the Station Hotel, Elland, was bought by Whitaker's when previous owners Brear & Brown of Hipperholme went into liquidation. In 1968, the pub transferred to Whitbread's ownership and in 1983, by then known as Bar-Bados, it was sold to West Riding Brewery and renamed The Barge and Barrel. The new name was more appropriate as the Elland station had closed in 1962 but the Calder and Hebble Navigation, which was completed in 1770, continues to bring passing trade.

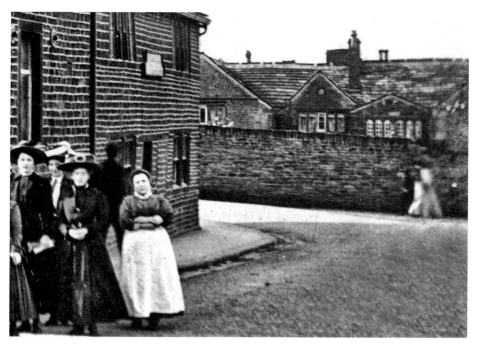

Over the wall in the distance is the Fleece Inn; nearer the photographer is the original Rising Sun Inn on Jepson Lane, an Elland landmark for over a hundred years. The pub was formed by combining two cottages previously occupied by the minister and the caretaker of Jepson Lane Baptist Chapel. The pub was rebuilt in 1913 at a cost of approximately £3,000 using stone from the chapel – which had also been demolished as part of the road-widening scheme to accommodate the new tramway to West Vale.

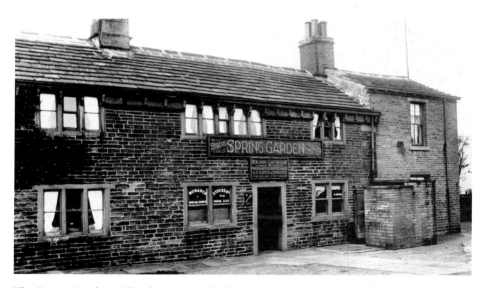

The Spring Gardens, Elland Lane, was built in 1810 and is now a Grade II-listed building. Benjamin Cartwright was landlord in around 1920, when this photograph was taken and the pub was operating as a Joseph Stocks house.

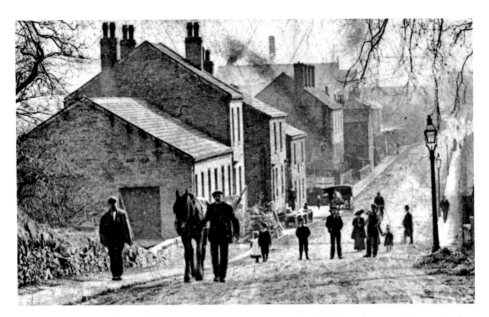

These people are posing for their photograph on what looks like a dirt track but is in fact Park Road, Elland. In the background, a man apparently riding a bike has just passed the Colliers Arms. This is another local pub where the origin of its name is disputed. Many believe that the name refers to actual coal miners, but it is more likely to have been derived from the flat-bottomed barges or 'colliers' that transported coal along the canal.

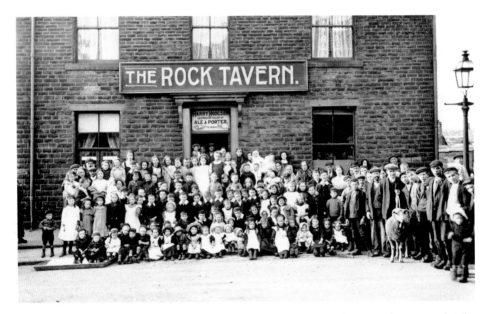

Ready to celebrate the Coronation of King George V in 1911, this crowd are outside The Rock Tavern, Upper Edge, Elland. The main event was a sheep roasting and the unknowing star of the show was on full view. Harry Hodgson, landlord at the time, was the conductor of the Brighouse and Rastrick Temperance Band; members had to sign a pledge of abstinence from alcoholic drink.

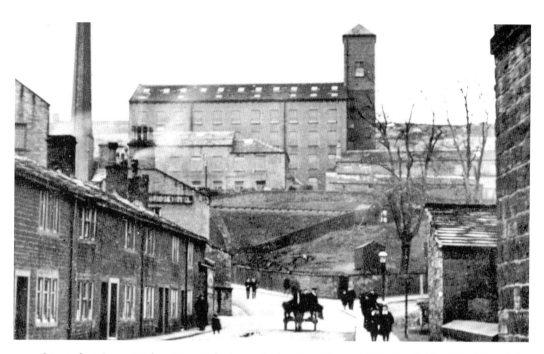

Located at Brow Bridge, West Vale, beneath the Clay House Mills, the Bridge Hotel faced the entrance to Clay House and its grounds. Mrs E. Walshaw was the landlady in 1905, around the time this picture was taken. The hotel closed in 1967.

Outside the Travellers Rest, West Vale, this is presumably landlord Dan Gill and his family. The Travellers Rest had its licence declined due to redundancy in February 1907, but Whitaker's made a substantial claim for compensation, which had the desired effect – the licence was restored. In 1919, the pub was offered to Whitaker's for £2,150, but the company considered the price too high and declined. The pub was eventually sold to J. Ainley & Sons. In 1957, it changed ownership again when Webster's purchased Ainley's Wappy Spring Brewery.

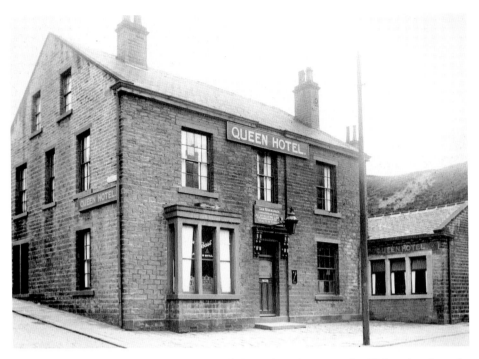

The Queen Hotel, West Vale, was one of the pubs taken over by Webster's when the company bought Joseph Stocks brewery in 1933. Sam Hemingway was the landlord when this photograph was taken in around 1920. It was still a Stocks house and was licensed to sell all intoxicating liquors.

A Ramsden's sign can just be seen on the Shoulder of Mutton at the bottom of Wellgate, Greetland. Although all the houses on the right have since been demolished, the three-storey building is still standing. It is now a private house. The pub closed in 1974.

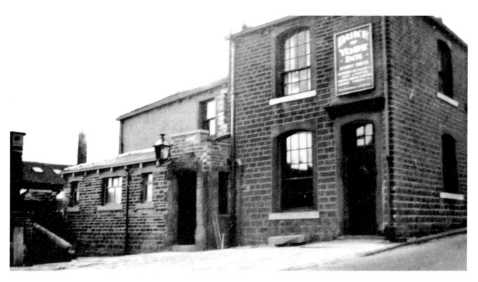

The Duke of York, Stainland, dates back to the early nineteenth century. John Walker was the landlord in 1822. At the Whitaker's board meeting held on 13 August 1896, it was stated that an offer had been made by Fred Buckley to let the brewery purchase the Duke of York for £2,500; the brewery declined. It was twenty-four years later, in 1920, that the pub eventually became tied to Whitaker's when the company bought the property, along with other premises, from Thomas Brown.

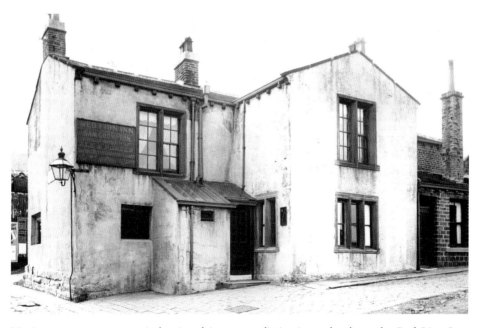

Having spent a recent period painted in a very distinctive red colour, the Red Lion Inn, Stainland, has now been restored to a more traditional 'white'. The pub is another of the Stocks houses that transferred to Webster's when the company took over the Shibden Head Brewery. The photograph was taken in around 1917, when Sam Crompton was the landlord. The pub was put on the market in 2010 with an asking price of £225,000.

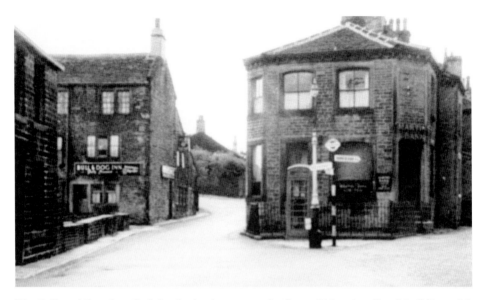

The Bull and Dog Inn, Stainland, also known as the Stone Ridge, is a listed building with parts dating back to the eighteenth century and the three-storey frontage dating from the early nineteenth century. The pub was owned by Brear & Brown until the company's demise in 1916, and subsequently by J. Ainley & Sons before that brewery was taken over by Webster's in 1957.

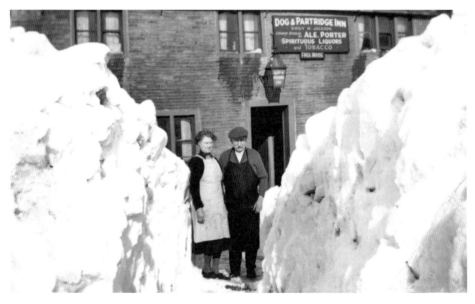

During the snowstorms of 1940 and 1947, the outer districts really bore the brunt of the bad weather. Standing outside the Dog and Partridge, Sowood, are (presumably) landlady Emily Jackson and her husband, who have done an excellent job of clearing a path for thirsty customers, who perhaps included the teams of volunteers that carried much-needed bread, potatoes and other supplies to some of the outer districts using sledges. A listed building, the pub dates from the late eighteenth century.

6

Down the Calder Valley

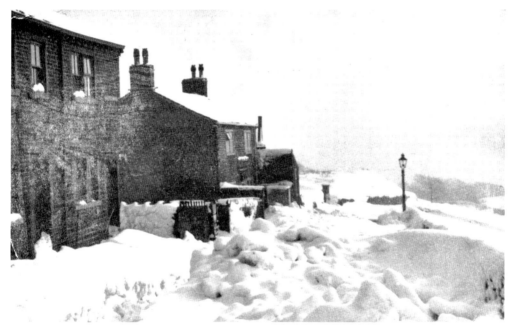

There are not many footsteps in the snow outside the Masons Arms in this photograph – taken in February 1953. Located in Winterburn Lane, Warley, the pub is now known as the Winterburn. In January 2006, the new tenants emptied the contents of the pub and shipped them to Paphos, Cyprus, where they set up a new pub, also known as the Winterburn. Following a lengthy police investigation, those responsible were later caught and sentenced at Bradford Crown Court.

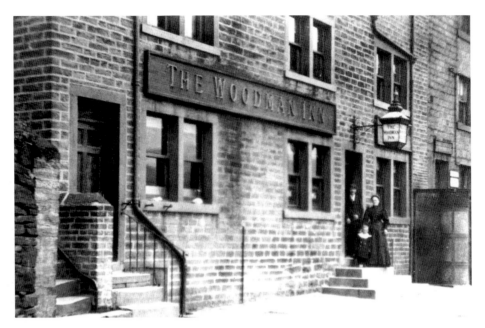

The Woodman Inn, which was located on Burnley Road, Luddenden Foot, closed in 1936. The pub, a Ramsden's house, was converted into cottages, but they were demolished in the 1960s along with other properties lining the main road. Next to the front door was a familiar sight at many local pubs: a large stone urinal. I'm not sure how many 'gents' will remember this type of urinal, but outside toilets were prevalent in Halifax for many years.

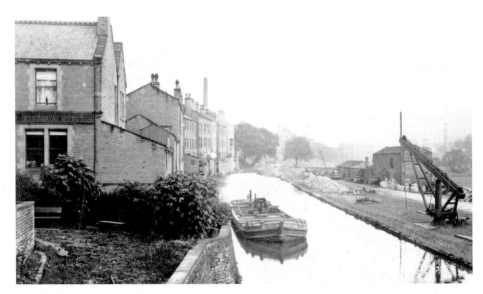

The barge, moored on the canal at Luddenden Foot, carries the title 'Engineer'. It would appear the bargeman has popped into the Victoria Hotel on the left. The Victoria Hotel was built in 1886, replacing another inn on the site, originally known as the Anchor and later as the Anchor and Shuttle. The Victoria Hotel closed in 1917 and the building was converted into offices for the urban district council.

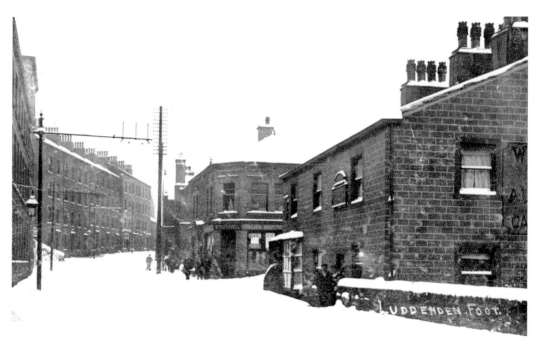

Known locally as 'The Bug Trap' – and we've all known a few of them – the Chatburn and Jennings on the corner of Station Road and Burnley Road, Luddenden Foot, was licensed in 1861. In 1904 the landlord was Jack Riley, who made 315 appearances playing rugby for Halifax between 1895 and 1907. He was part of the team that achieved the double in 1902/03 and went on to win the Challenge Cup again in 1903/04; he also achieved county honours playing for Yorkshire. The Chatburn and Jennings closed, due to redundancy, in 1923.

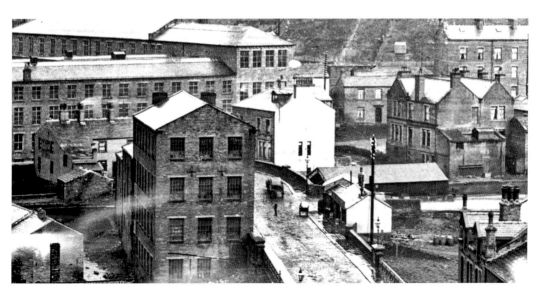

The Chatburn and Jennings can be seen on Burnley Road in this view looking along Station Road, Luddenden Foot. On the right is the Victoria Hotel, while standing in Station Road someone is looking towards the building that would later become the Old Brandy Wine.

One of the earliest mentions of the Shoulder of Mutton, Mytholmroyd, is in 1822, when Isaac Ogden was the landlord. The pub was later owned by Grove Brewery, Whitaker's and Whitbread. In 1896, the Lancashire & Yorkshire Railway proposed changes to the nearby line that threatened the pub. Fortunately for the Shoulder of Mutton, the plans did not materialise.

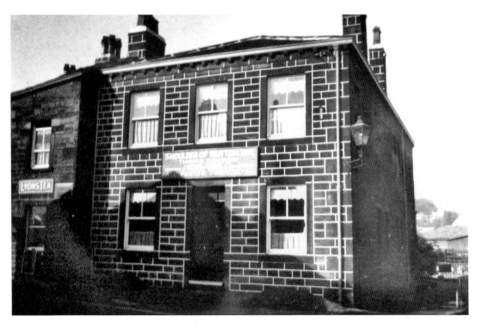

This photograph of the Shoulder of Mutton was taken in the 1940s when Whitaker's were considering alterations amounting to £1,500, including 'new lavatory accommodation' so that customers would not have to go outside. Presumably the toilets were at the rear of the pub, overlooking the area where the village ford and stepping stones once crossed the Elphin Brook.

The Grove Inn was built in the 1830s, on the Halifax-to-Burnley turnpike road. In 1859, George Bedford established his brewery on land adjoining the Grove Inn. In 1905, George Bedford Whitaker, a nephew of the chairman of Whitaker's brewery, was running the Grove Brewery when he was invited to join the larger Halifax concern.

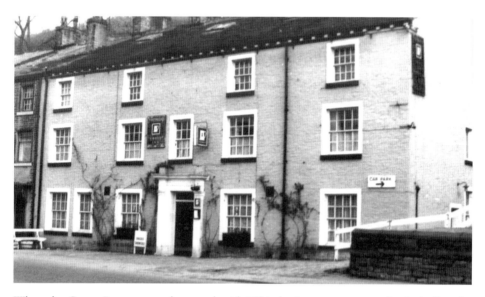

When the Grove Brewery amalgamated with Whitaker's, over twenty pubs, including the Grove Inn itself, were transferred to the Halifax brewery. Grove Brewery closed in 1906 but the inn continued to run until 2008.

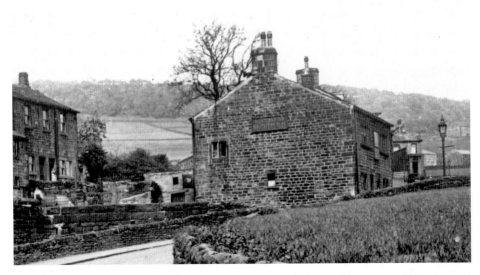

The Huntsman Inn was located on Midgley Road, Mytholmroyd. The inn, which obtained a full licence in 1952, was a Whitaker's house until the company's takeover by Whitbread in 1968. The Huntsman closed four years later in 1972.

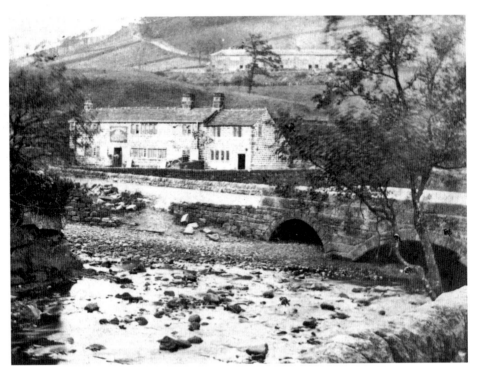

Dating from the 1860s, this is a rare photograph of a barely recognisable pub. It was rebuilt in 1879, although the cottage at the end was not rebuilt until 1912, which makes identifying the Cragg Vale Inn much easier. It was in around 1912 that a new entrance was built and the inn was renamed the Hinchliffe Arms, after the Hinchliffe family, who owned several mills in the area.

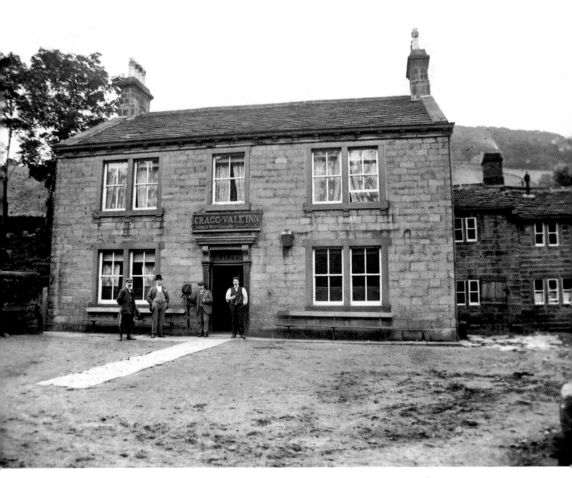

Taken from a glass slide, this photograph shows the rebuilt Cragg Vale Inn when Thomas Whittingham was the landlord, i.e. around 1905. On 7 August 1899, customers would have been surprised to witness a huge balloon flown by aeronaut, Ruben Bramhall. With his assistants Mr Dawson and Mr J. H. Robson, Bramhall landed in a field near the inn; the journey from Bradford had taken them forty-five minutes.

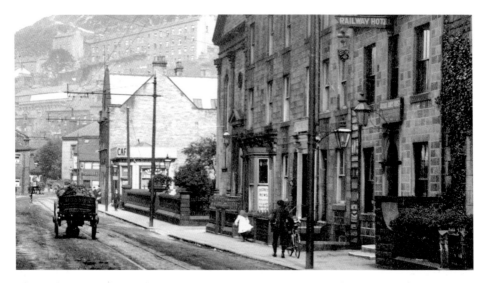

The Railway Hotel, Hebden Bridge, was built in 1861, alongside New Road and near to the Hebden Bridge railway station, which had opened in 1840. In 1888, proprietor George Bloomer advertised the conveniently located premises. Unfortunately he died on 15 February that year, aged twenty-eight years. The pub was taken over by Franklin Clayton, whose advertisements included a short rhyme: 'His tap's the choicest to be had,/The best food's on his shelf,/Call at the Railway Inn, my lad,/If you'd enjoy yourself.'

One of the oldest buildings in Hebden Bridge, bearing the date 1657, the White Lion was originally known as King's Farm, after its then-owners. One of its most famous customers was Franz Liszt, the Hungarian composer and pianist who, having performed a piano recital in York, called at the hotel for breakfast in December 1840. The young lad who has just cycled past the hotel is reminiscent of scenes from the 1949 film *A Boy, a Girl and a Bike*, which was filmed in the area and featured a young Diana Dors and Jimmy Saville as an extra.

The White Horse Hotel was built in around 1786 by William Patchett on a site previously known as Bannister's Farm. Shortly afterwards, William opened his inn in direct competition with his brother, Richard Patchett, who ran the White Lion Hotel, which had an advantageous position on the turnpike road. However, William Patchett proceeded to construct a new road that cut the White Lion corner off. During discussions with the turnpike trustees, he persuaded them to adopt the new road.

The White Horse closed in 1960 and the property – which had been bought by Whitaker's in 1921 – was sold in 1961 to the Hebden Royd Town Council for £3,500. The premises were demolished the following year.

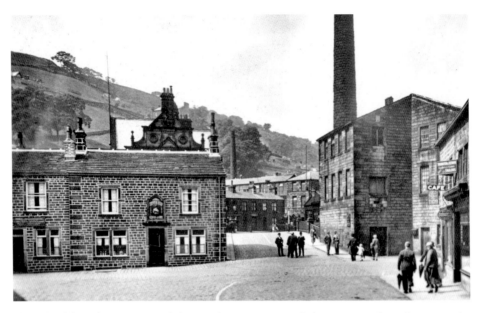

The Shoulder of Mutton, Hebden Bridge, was one of the many pubs taken over by Whitaker's when the company purchased the Grove Brewery and its houses in 1905. In 1894, landlord J. W. Law – apart from offering good stabling, dinners, teas and refreshments – also published the following advertisement: 'If tourists want a bottle of reliable spirits for their pocket, for the return journey, the best can be obtained at the Shoulder of Mutton.'

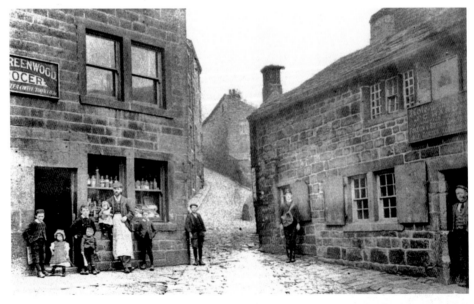

Dating from the seventeenth century, the original Hole-in-the-Wall, Hebden Bridge, was demolished following the building of its replacement in 1899. The new pub was built to the rear of the original inn, presumably to retain continuity of the licence. While the old pub was waiting to be demolished, customers would walk through it to gain access to the newly erected building.

In August 1889, the Bull Inn, Bridge Lanes, Hebden Bridge, was the location for the inquest into the death of William Clarke. Despite considerable evidence of foul play, the coroner's verdict was that 'he died from injuries received from a fall, without sufficient evidence to show how such a fall came about'. He had fallen (or been pushed) from a third-storey window at the Dog and Partridge Inn, Heptonstall, following a heavy drinking session and much – for want of a better word – 'jollification' with some ladies. The verdict caused rioting among the hundreds who had gathered for the inquest and who clearly disagreed with the findings. The licence of the Dog and Partridge Inn was withdrawn on 10 October that year.

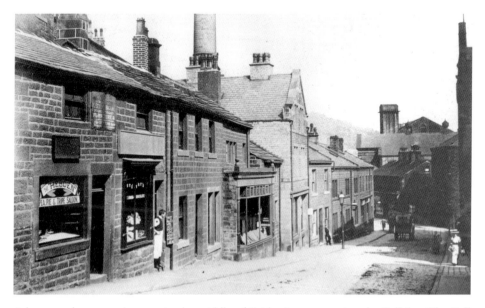

A horse and cart can be seen in the middle of Bridge Lanes, passing the Bull Inn. The Bull Inn closed in the 1970s.

The Fox and Goose, Hebden Bridge, was another Grove Brewery house taken over by Whitaker's. In a survey carried out by the brewery in the 1930s, the company stated that 'owing to the peculiar position of this house, there is nothing that could be done that would improve it unless it was entirely rebuilt taking away part of the hillside'. Despite these adverse comments over seventy years ago, the pub – now privately owned – continues to be successful. It was CAMRA Halifax Pub of the Year in 2006 and was runner-up in CAMRA Yorkshire the same year.

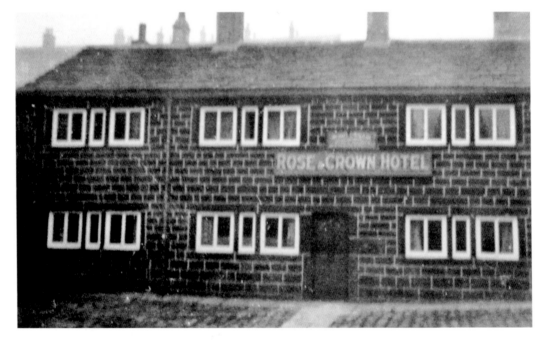

The Court Sublime Lodge of the Royal Foresters met at the Rose and Crown, Castle Street, Todmorden, until 1893. On 4 February that year, it was reported that the lodge was dissolved and the members, then numbering eighty-eight, received £10 10s each from the first division of proceeds. In October 1894, the then-owners, the Sutcliffe family, sold the pub to Whitaker's brewery. In 1896, the pub was under threat due to proposals by the Lancashire & Yorkshire Railway. Whitaker's replied, 'dissenting' to any construction.

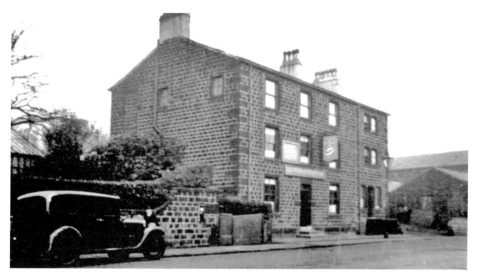

On 1 June 1813, HMS *Shannon*, a thirty-eight-gun frigate under the captaincy of Philip Broke captured the USS *Chesapeake* off Boston Harbour. The battle, during the American War of Independence, has gone down in history as the finest single-ship action in the age of sail. Named after the two ships, the Shannon and Chesapeake in Millwood, Todmorden, was built in around 1817. The inn was sold to Whitaker's brewery in 1894.

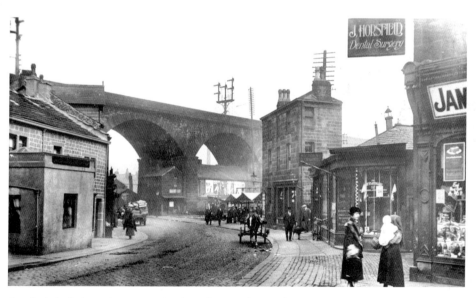

On the left, facing what is now Todmorden Market, is the original Black Swan. The building was originally a carriers' warehouse but became an inn when the nearby Patmos Inn closed; its licence was transferred to the Black Swan in the 1790s. The building once contained the lock-up cells for Todmorden and Walsden prisoners. On 1 July 1884, an inquest was held at the Black Swan into the death of five-year-old Dorothy Bouchier, who died suddenly from the effects of eating gooseberries and green peas. In 1932, then in the ownership of Massey's Brewery, the old building was replaced with the present structure, which is now known as The Polished Knob.

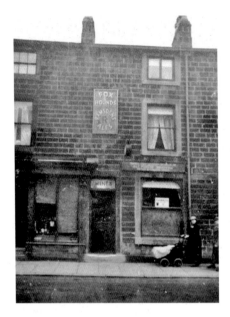

The Fox and Hounds Inn, Patmos, Todmorden, was built in around 1840. On 8 April 1913, a disastrous fire occurred, which started under a wooden staircase and caused between £400 and £500 of damage. The pub is seen here as a Ramsden's brewery house shortly before being sold to Richard Whitaker & Sons in the 1930s.

Whitaker's bought the Fox and Hounds Inn, Todmorden, in 1937, taking the opportunity to also purchase the shop next door. This gave the brewery the opportunity to not only renovate the existing premises but also considerably enlarge it, at an estimated cost of £2,000. The pub was transferred to Whitbread in 1968 when the company took over Whitaker's brewery.

Known originally as the New Inn, the Hare and Hounds, Todmorden, opened in the 1820s. Next to the inn was Holme Field, a location for the popular annual circus before Hare Mill (later Mons Mill) was built in 1909.

In August 1891, customers of the Hare and Hounds would have witnessed the incredible sight of Miss De Voy make a balloon ascent at Holme Field, followed by descent by parachute. It was even more remarkable given that her two former associates – Professor Higgins and a man named Lennox – had both recently died, in separate incidents, attempting the same feat.

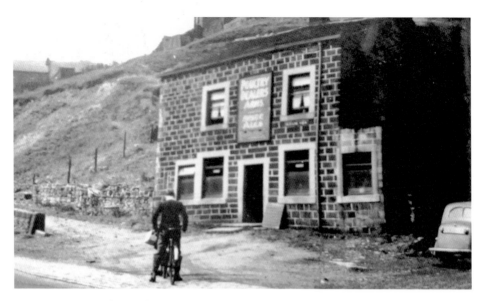

Now a private residence, the Poultry Dealers Arms was at Kitson View, Kitson Wood Road, Todmorden. The pub was formerly owned by Grove Brewery, Brearley, which was taken over by Whitaker's in 1905. In 1968, Whitaker's itself was taken over and 'the Poults' became a Whitbread house.

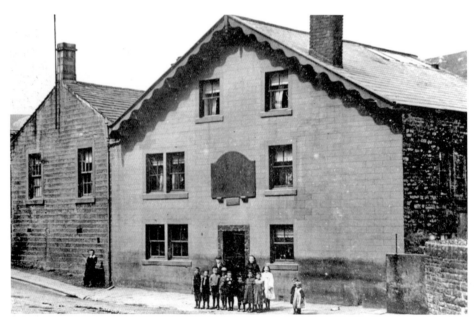

Dating from the early 1770s, the Roebuck Inn is in Portsmouth, Todmorden. The area was given its name by the son of Thomas Clegg, the pub's first landlord, who had returned to the village having served in the navy at Portsmouth. Over the years, the inn and surrounding areas have been subject to many floods. On 14 July 1870, an inquest was held at the Roebuck Inn into the death of two-year-old Sarah Goodall, who had perished along with her older sister Betsy in the devastating floods that took place that year.

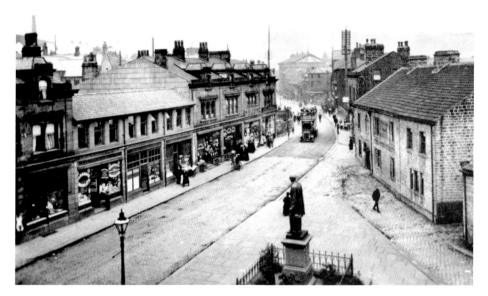

Built in around 1770, the Golden Lion has served Todmorden in many guises, including as an important coaching inn – when the Shuttle and Perseverance stagecoaches passed through the town each day – and also as the venue for many important gatherings. In 1854, a meeting was held here regarding the rebuilding of Stoodley Pike, which had collapsed at the start of the Crimean War.

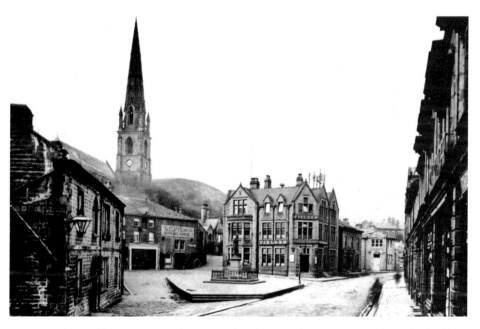

In 1860, the Golden Lion was the venue for the initial meeting regarding the building of Todmorden Town Hall. The following year, the first meeting of the Todmorden Local Board was held at the inn. The Todmorden Prosecution Society, Todmorden Book Club, Todmorden Football Club and Todmorden Agricultural Society have all held their meetings at the Golden Lion.

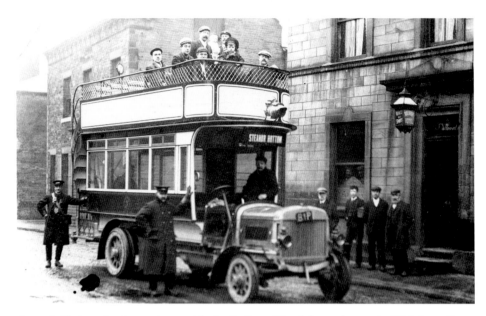

An early Todmorden bus waits outside the Railway Hotel, located opposite Walsden railway station. In June 1882, it was reported that a man from Whitworth had placed a bet that, from the Railway Hotel, he could get to Stoodley Pike and back in less than an hour. He won his bet, taking only fifty-two minutes. On 27 March 1909, the St John's Lodge of the Royal Antediluvian Order of Buffaloes was founded at the Railway Hotel. The pub closed in 1969.

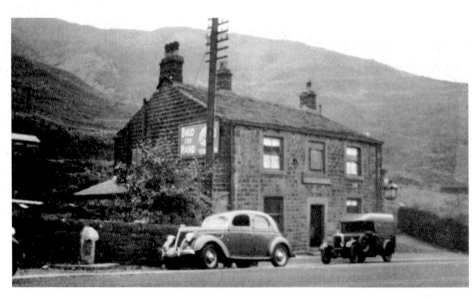

The Bird I'th Hand, Todmorden, was built in around 1825 on the new turnpike road from Warland to Littleborough. This replaced an older 'Bird', at Calf Holes, which was on the old road to Littleborough. The new inn, standing only yards from the border with Lancashire, was originally owned by Joshua and John Fielding, who, in 1828, leased the pub to William Rogers, the son of Henry Rogers, who had been the landlord at the older Bird I'th Hand. In 2011, the pub was for sale at an asking price of £195,000.

7

Sowerby Bridge and the Ryburn Valley

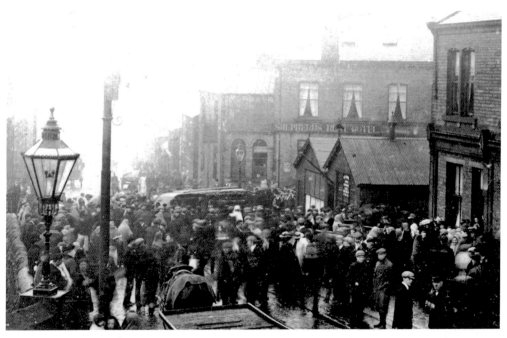

The worst accident in the history of Halifax Corporation Tramways occurred on 15 October 1907. A tramcar packed with passengers was climbing the road up Pye Nest, Sowerby Bridge, when the car ran back down the hill before crashing into a shop. The impact ripped the roof off the tramcar. Many of the injured were treated at the nearby Shepherds Rest Hotel, where the landlady also handed out 'stimulants' to the injured and supplied sheets, blankets and any other items that were needed.

A vehicle belonging to the Halifax Industrial Society is passing Whitaker's Brown Cow Inn. On the junction of Wakefield Road and Bolton Brow, Sowerby Bridge, is the Prospect Inn. The etched lower windows of the inn advertise Stone Trough Ales, indicating that the pub was a Ramsden's house. The building is now the Prospect Veterinary Centre.

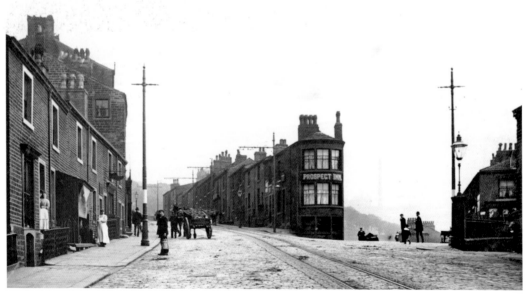

The area around the Prospect Inn, Bolton Brow, was well served with public houses. Many of these – such as the Queen Inn, the Oddfellows Arms, the White Lion Inn and the Brown Cow – are, like the Prospect, long gone.

The Wharf Hotel, Sowerby Bridge, was originally located across the road in Cawsey House, alongside the old packhorse route. It became a pub in 1747 and was known as the Mermaid, but changed its name to the Wharf Hotel in 1898. In 1922, the licence was transferred to the present building, which retained the same name until 1983, when it became the Ash Tree. It is now known as the Village Restaurant.

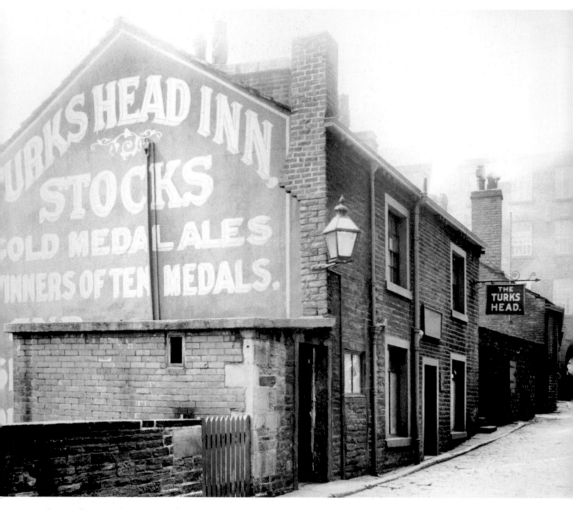

The Turks Head Inn, located at Back Wharf Street, Sowerby Bridge, was another of the Joseph Stocks pubs purchased by Webster's in 1933. Speculation regarding the pub's name has been ongoing for as long as anyone can remember. Is it a reference to the enemies of the Crusaders, or to the Barbary Pirates who made raids on the shores of Europe, including Britain? Or was it named after the 'Turks head brush', which would have been used by nearby boat or barge owners? The pub had been a beerhouse for well over a hundred years before it obtained a full licence in 1960; a conclusive answer is unlikely to be forthcoming.

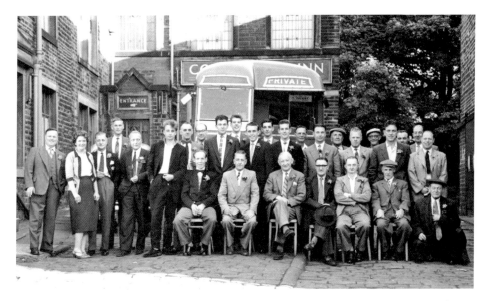

Posing for their photograph prior to a trip, these gents are outside the Commercial Inn, Sowerby Bridge, in an area once known as Albany Square. At the front, second from the left in his light-coloured suit, is Raymond Carr Lumb, who ran the chemist's shop next to the Commercial Inn. Raymond often stated that he did not have to go outside to visit the Commercial Inn as he had a direct connection from inside his shop. Whether this was true or not, he did not have far to walk.

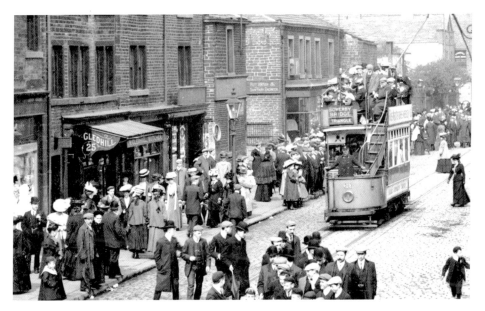

On its way to Triangle, the tramcar is outside the Commercial Inn – now known as The Wharf after a spell as The Lock Keepers. Albany Square can be seen next to the pub, which disappeared when Tuel Lane was realigned in 1968, although the area is now part of The Wharf's beer garden and car park. The buildings to the right were also demolished. The one proud of the block, behind the tramcar, was the Red Lion Inn.

The Red Lion Inn, Sowerby Bridge, was referred for compensation in 1906. At the brewster session, it was pointed out that Sowerby Bridge had forty-seven licensed premises for a population of only 11,437. The owner pointed out that the area also had a floating population – perhaps a point noted by the West Riding Compensation Authority, who stated how dangerous the pub was since it opened out onto the canal. The chairman also questioned the darkness of the inn and the defence replied, 'The inn was not dark but had a sort of dim, religious light, which accounted for the good behaviour of the customers.' Despite this, the justices refused to renew the licence and the inn was closed.

The Branch Inn was located next to the large block of mills, which included Siddall & Hilton and Pollitt & Wigzell on Wharf Street, Sowerby Bridge. The pub was owned by John Naylor's Albion Brewery and after 1919 by Thomas Ramsden & Son, who at the same time took over the brewery at Cote Hill, then trading as the Warley Springs Brewery. In 1949, the Branch Inn was referred, on grounds of redundancy, and closed the same year.

The building that housed the Town Hall Tavern was built shortly after Sowerby Bridge Town Hall was completed in the 1860s (the clock was installed in 1863). It originally abutted the town hall building – the part where the car park still exists. The pub, a former Grove Brewery house, was purchased by Whitaker's in 1905, became a Whitbread house in 1968, and later a free house selling Tetley's Ales. It too was demolished, making way for apartments on Hollins Mill Lane.

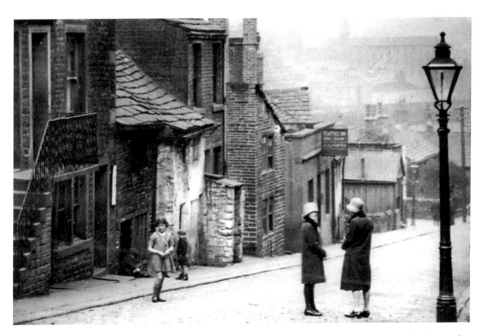

The sign for the Pear Tree Inn, hangs on the building behind the two ladies stood in Sowerby Street. John Cockroft was the landlord when this photograph was taken. In August 1840, Branwell Brontë became a booking clerk at Sowerby Bridge railway station and is reputed to have resided here with the Bates family. The Pear Tree Inn closed in 1927.

This photograph shows the side of the New Inn looking towards The Nook, Sowerby Bridge. The pub is now named Long Chimney, after the octagonal mid-nineteenth-century chimney located at the junction of Lower Brockwell Lane and Rochdale Road.

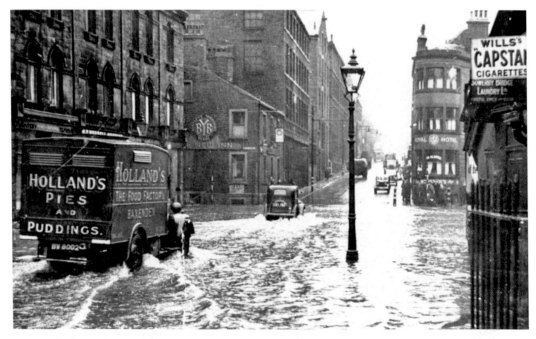

The floods of 1946 brought devastation to many local areas; here we see the floodwater by the Royal Hotel and outside the New Inn, Sowerby Bridge. In March 1875, Benjamin Thwaite, landlord of the New Inn, was brought in front of Sir Henry Edwards at the West Riding Court for allowing drunkenness in his pub. In his defence he stated that he could not help it, as the new railway had broken down and the pub was full of navvies who were very rough. Despite having turned them all out twice, they were always replaced by more navvies. The court was unsympathetic and fined him 10s and 7s 6d costs.

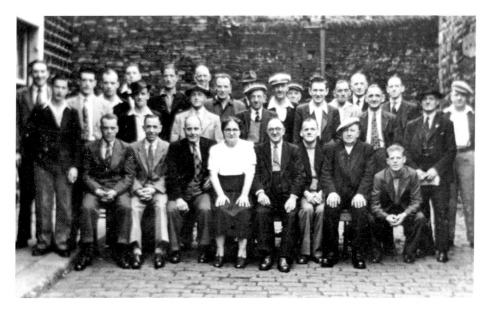

This group is posed outside the Stirk Bridge Inn, on the then-cobbled Scarr Head Road, Sowerby Bridge. An inn has existed at Stirk Bridge since the sixteenth century, when packhorses would have crossed over the nearby ford.

The Stirk Bridge Inn derives its name from the bridge local farmers would have used when they drove their cattle to market (a stirk being a young heifer or bullock). In 1686, the constable of Sowerby paid 9s 5d for the making and erecting of a ducking stool at Stirk Bridge – a punishment for a number of crimes including the brewing of bad ale.

The Church Stile Inn is located in Stocks Lane, opposite St Peter's Church, Sowerby. The present church is the third on the site, and was completed in 1766. Entrance to the previous church was by a flight of steps called Church Stile, which gave its name to the area and subsequently the pub.

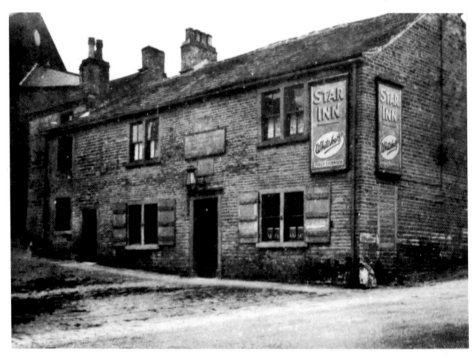

The Star Inn, Sowerby, was built in 1798 by Captain Jennings, the first landlord. John Almighty became landlord when he married Captain Jennings's widow and is the pub's most renowned character. Apart from being the publican, John Almighty took on many other roles in the village: auctioneer, constable, hedge-lawyer and preacher. His Sunday evening services, conducted in the tap room of the inn, attracted large audiences. The pub is now known as the Rushcart Inn; it is a stopping point during the annual Sowerby Bridge Rushbearing Festival.

Perhaps the gentleman leaning on the wall has just come from the King's Head Inn. The photograph is taken from outside St Peter's Church, the third church on the site and built following meetings held in the King Head Inn in the 1760s, when John Garnett was the landlord.

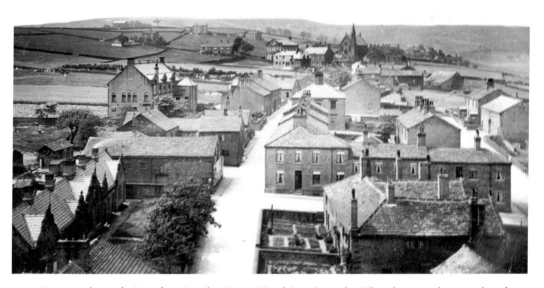

A more elevated view showing the King's Head Inn, Sowerby. The photograph was taken from the top of the church tower of St Peter's. The Sowerby Almshouses, on the near side of the pub, were built in 1728 by Elkanah Horton and rebuilt in 1862 by John Rawson.

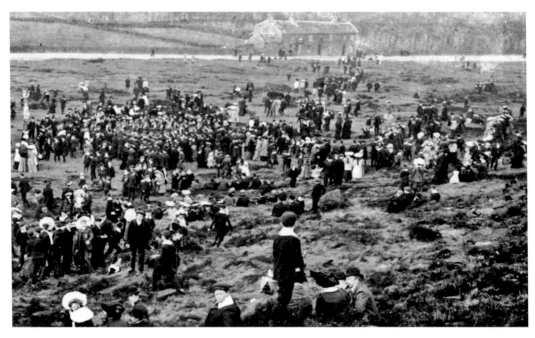

A large crowd enjoying the moors at Norland look down towards the Moorcock Inn in 1905. A lot of those present look too young to partake of the alcoholic refreshments then served by Henry Jackson, who was the landlord when this photograph was taken.

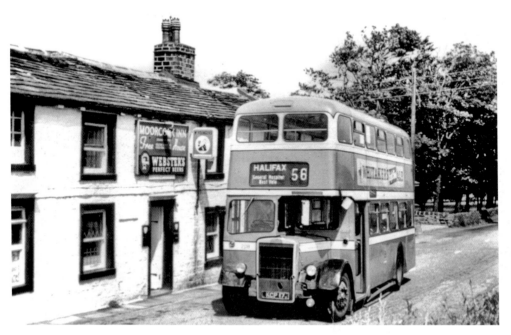

A Halifax bus advertising Whitaker's Light Shire Ale passes the Moorcock Inn, Norland. The large sign on the pub states that it is a free house and advertises Webster's Perfect Beers. Alongside this is the sign for William Younger's displaying the familiar trademark figure 'Father William'.

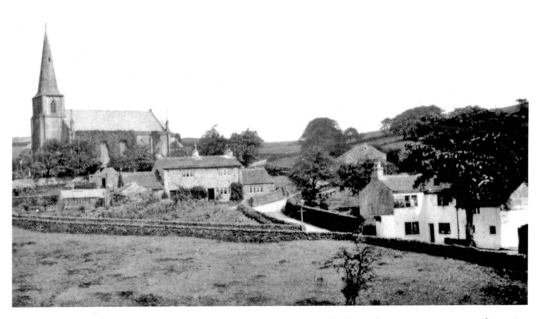

Dating back to the early nineteenth century, the Friendly Inn, Cottonstones, was a favourite venue for workers at the nearby Lumb Mill, which was occupied by Lilywhites, producers of photographic picture postcards. Unfortunately the mill burnt down on 15 January 1931 and Lilywhites moved its production to Mearclough, Sowerby Bridge. The pub closed five years later, in 1936, and is now the Friendly Inn Farm.

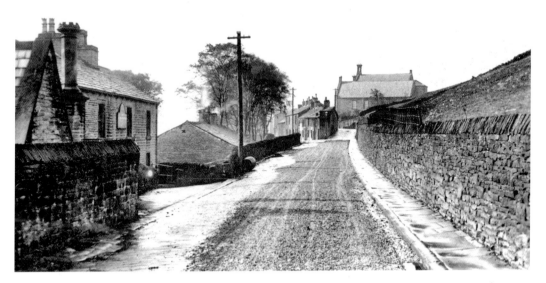

The Anchor Inn, Mill Bank, once claimed to have the largest inn sign in Great Britain. The giant anchor that used to be suspended outside the pub came from a boat in Whitby that was destined for the breaker's yard. The parish of Halifax has had many pubs of the same name but mainly on the canal bank. With the Anchor Inn being inland, the real origin of its name is unclear. Given the hilly surroundings, it is likely linked to the anchoring of carts or wagons. Having spent recent years as the Millbank restaurant, the pub closed in 2010.

The Brown Cow Inn was located in Godly Lane, Rishworth. The building dates from the seventeenth century, with eighteenth-century alterations. The property changed little in over hundred years as a beerhouse. This fairly blurred photograph from 1940 presumably shows the luxurious lavatory facilities on the right.

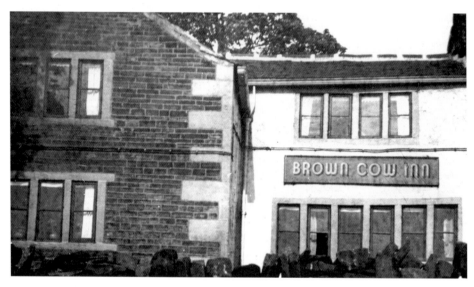

In January 1920, Lord Savile announced his intention to sell the pub, with an asking price of £750; Whitaker's purchased the pub in September. The pub closed in 1955 and the building is now a private residence.

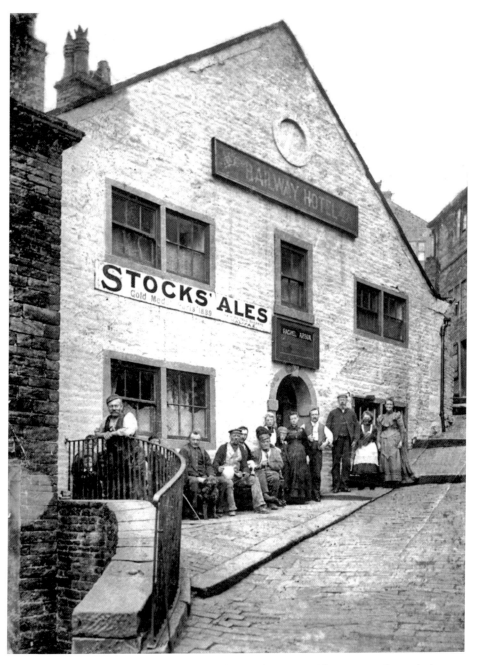

The Railway Hotel was located at Ripponden Bank Bottom. The inn was formerly known as The Canterbury Inn, but was renamed with the coming of the railway to Ripponden in 1878. In 1906, the inn was referred for compensation, but at the West Riding Compensation Authority it was pointed out that the inn was in bad condition and damp and that its customers were largely tramps and vagrants. Its licence was refused. At the time, Rachael Abson had been the landlady for twenty-five years.

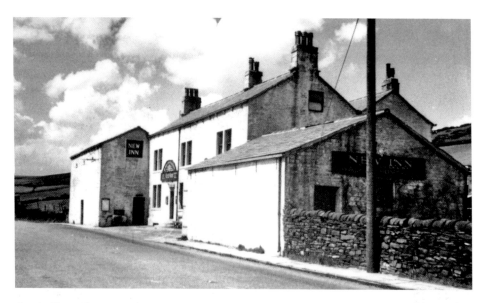

On 24 December 1832, an inquest was held at the New Inn, Ripponden, concerning the death of Daniel Holroyd, 'who with some fellow workmen had been drinking some footings until late'. During a quarrel he was struck by a man named Kershaw with such force that he died instantly. Kershaw was sent to the York Assizes, accused of manslaughter. The pub was built in around 1750 on the new Halifax-to-Rochdale turnpike, and was closed in 2000 following a farewell party given by landlady Helen Diffin, whose family had run the pub for over twenty years.

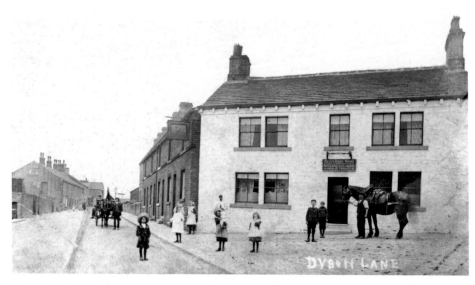

Parts of the White Hart, Ripponden, date back to 1630, with additions being made in the eighteenth and nineteenth centuries. An 1816 indenture shows that Roger Peel was then the occupant of the inn, which was already bearing the sign of the White Hart. It also lists John Howarth – possibly the renowned eighteenth-century lawyer – as a previous owner. The White Hart closed in the 1990s and was subsequently converted into cottages.

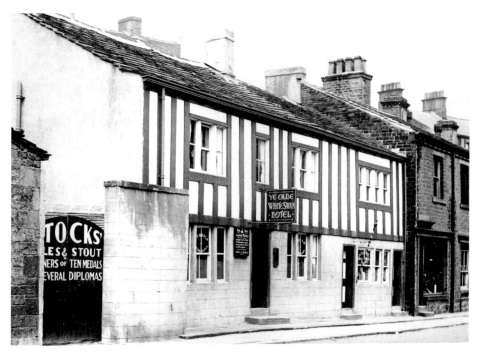

The White Swan, Ripponden, was originally known as the Waggon and Horses and it was under this name that it was purchased by Michael Stocks in 1869. In this photograph, taken in around 1915, the inn bears the sign 'Ye Olde White Swan Hotel'. The ornate 'barber's pole' shows that part of the premises was used as a hair salon (by D. Crossley).

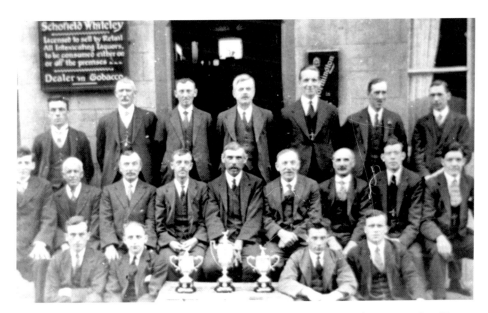

Schofield Whiteley was the landlord of the White Swan when the Ripponden Pigeon Fanciers posed for this picture along with their silverware. The premises, including the part previously used as a hair salon, are now The Fox Bar and Bistro.

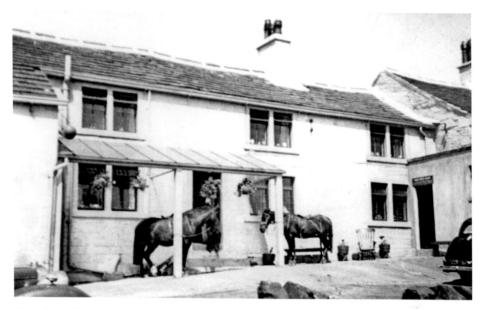

The Blue Ball Inn, Soyland, has an interesting history linking it to highwaymen and coiners. In the 1770s, landlord James Proctor was listed with many others as suspected of coining; other stories refer to another landlord, Iron Ned, the leader of a notorious gang who is believed to have murdered a local girl called Faith, a worker at the inn.

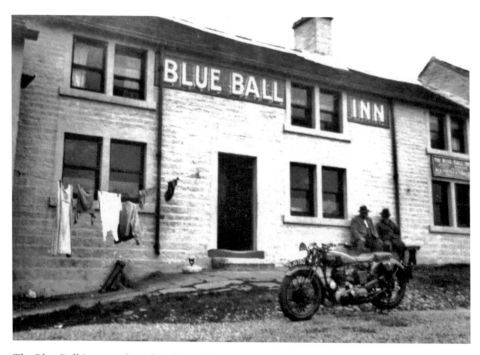

The Blue Ball Inn stood on the old packhorse route over Blackstone Edge. The inn bears two dates, 1672 and 1846, presumably the latter was when alterations were made to the ancient property. The pub was converted into private housing in 2002.

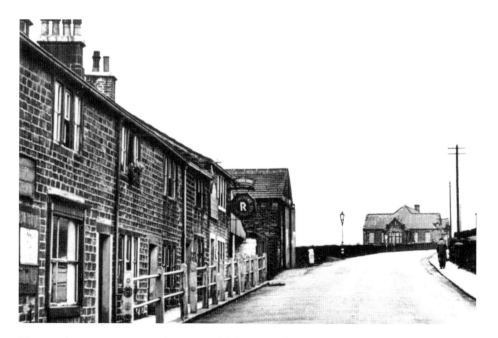

The Butchers Arms, Ripponden, started life at the far end of the row of late eighteenth-century cottages along the turnpike road to Lancashire. The Rochdale to Halifax and Elland Turnpike Act of 1735 was one of the earliest in the country and the first locally. The Butchers Arms is a listed building that may at one time have housed a textile-manufacturing shop on the first floor, with living accommodation below. Seen here as a Ramsden's house, the pub gradually extended to take over the entire row of cottages.

In the early nineteenth century, the cottages were overshadowed when Henry Binns built his Dyson Lane Mills. In this photograph, the earliest known of the Ripponden area, dating from around 1852, the Dyson Lane Mills stand on the other side of the lane, opposite the cottages, which are now the Butchers Arms. Daniel Clayton was the landlord in 1905 and his view and clientele would have changed considerably when the mills, including the 130-foot chimney, were demolished that year.

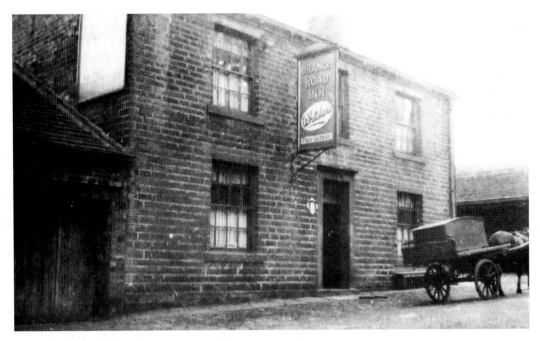

Whitaker's brewery bought the Branch Road Inn, Barkisland, in 1919 for £1,250. The pub had previously been tied to James Alderson's Warley Springs Brewery. In the late 1930s, Whitaker's considered the possibility of building new premises nearer to West Vale and transferring the licence – mainly because there were no public services, including a water supply, to the inn at the time.

These gents look to have enjoyed their carry out in Norland. It may have been provided by one of the nearby pubs, perhaps the Foresters Arms or the Blue Ball Inn. Sat in the middle with the two flagons is Harry Wood, with Wilf Butterworth and Fred Wood on either side of him.